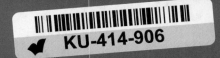
THE
NATIONAL
GALLERY
IN WARTIME

SUZANNE BOSMAN

NATIONAL GALLERY COMPANY LONDON

DISTRIBUTED BY YALE UNIVERSITY PRESS

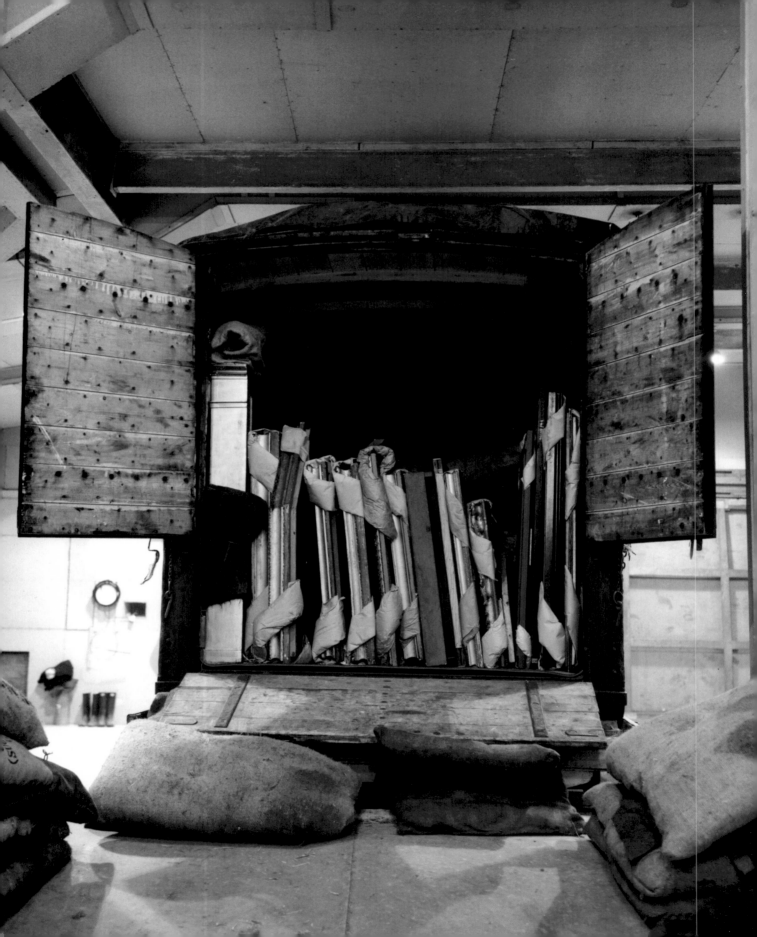

Contents

The gathering storm

When looking at Trafalgar Square and the façade of the National Gallery today, it is difficult to imagine the dramatic events that took place there some seventy years ago. This is an account of the National Gallery during those war years and of the efforts made to protect the paintings while preserving the institution's cultural role in a time of threat.

It was not the first time that the Gallery had to take exceptional measures to safeguard the nation's paintings. During the First World War, German zeppelins had carried out sporadic bombing raids on London and other major cities, killing and injuring hundreds of people and causing local – but nevertheless severe – damage at a time when the bombing of civilian centres was as yet mercifully rare. At that time the National Gallery, aware that the building was a major landmark and therefore a possible target, had evacuated a number of its paintings to the tunnels of the disused station in the Strand (later renamed Aldwych) belonging to the Underground Electric Railways of London.

In 1934, the National Gallery appointed its youngest director ever – Kenneth Clark, fresh from his post as Keeper of Fine Art at the Ashmolean Museum in Oxford. He arrived to take up his new position at the age of 30 and in the years that followed, a number of innovations were brought in: artificial lighting was introduced into the galleries for the first time, the opening hours were extended and a scientific laboratory was established, and as early as 1934 the Gallery authorities set out a preliminary plan for the safe removal of paintings to locations outside London in the event of another war.

By 1936, the expansionist policies of both Germany and Italy convinced many that it was only a matter of time before another major conflagration engulfed Europe. The occupation by Hitler's forces of

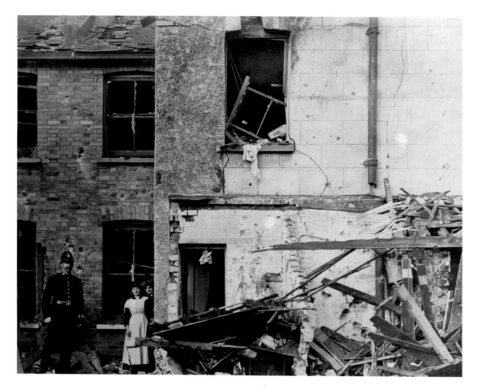

LEFT Zeppelin raids on London and other major cities during World War I caused many casualties and substantial damage. The danger to London's monuments prompted the National Gallery to shelter a number of selected works in tunnels of the Underground system.

BELOW During the Spanish Civil War, Hitler intervened on the side of General Franco, and the Luftwaffe's Condor squadron carried out saturation bombing of Madrid and Guernica – the ruins of which are seen here – in a strategy that came to be seen as a 'practice run' for the wider conflict on the horizon.

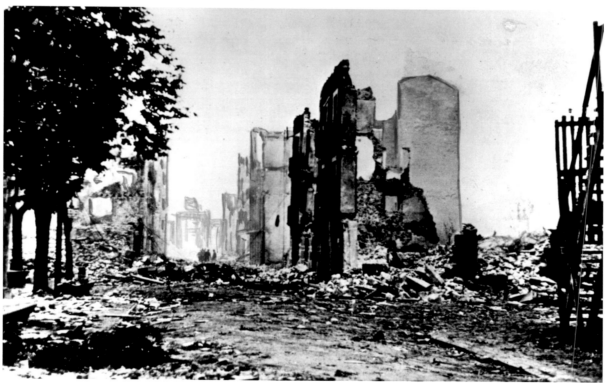

BELOW Hitler on his way to
Vienna after the annexation
of Austria by Germany. The
banner reads: 'Lower Austria
welcomes its Führer'.

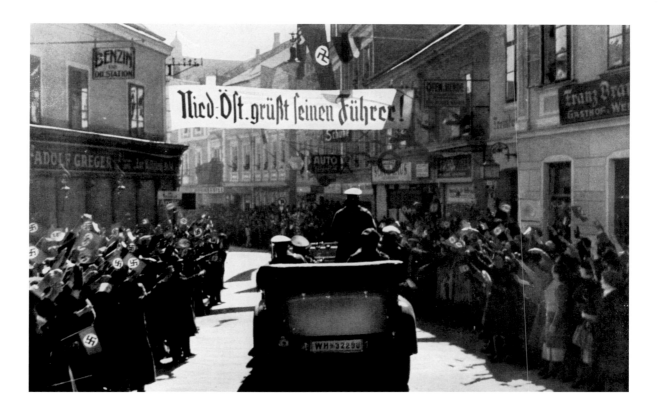

the demilitarised zone of the Rhineland,
Mussolini's invasion of Abyssinia, and
Germany's support for General Franco in the
Spanish Civil War, all served to reinforce the
belief that conflict was inevitable. It was clear
from the saturation bombings of Guernica and
Madrid carried out in 1937 by the Luftwaffe
during the Spanish Civil War, and in China
by the Japanese air force, that a military
confrontation was likely to involve the
bombing of civilian centres of population at
unprecedented levels. Hitler's expansionist

aims were made evident with Germany's
annexation of Austria in March 1938, and
his designs on Czechoslovakia brought
matters to a head.

In September, the leaders of Germany,
Italy, France and Great Britain gathered in
Munich to discuss the fate of Czechoslovakia.
It had been made plain by the governments of
France and Great Britain that any violation of
Czechoslovak borders would be seen as a direct
threat to the provisions of previous treaties.
But Germany was equally adamant that it had

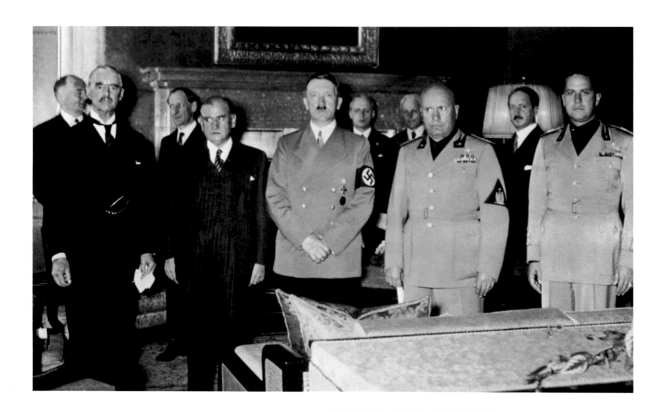

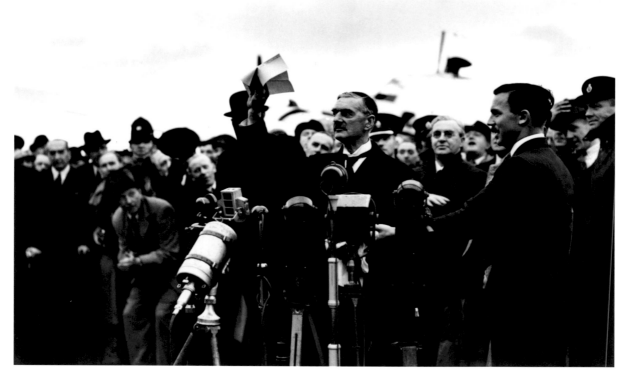

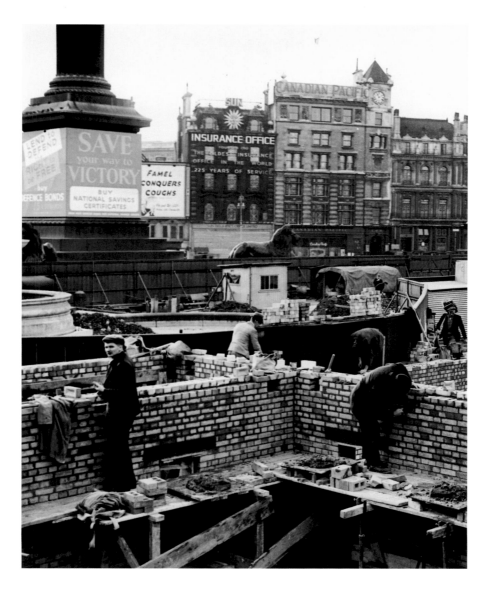

a territorial claim to parts of Czechoslovakia. Negotiations at the conference were tense, and by the end of September a declaration of war was expected at any moment. As military strategists believed that any commencement of hostilities would be accompanied by extensive bombing, the National Gallery investigated options for a more widespread evacuation of the paintings, and sent a first consignment of masterpieces to Wales during the last days of the conference.

As it turned out, war was averted in the short term. Britain and France backed down, and Czechoslovakia was abandoned to its fate. Neville Chamberlain returned to England, waving the paper that he had signed and proclaiming that he had achieved 'peace in our time' – but the peace was short-lived.

RIGHT Kenneth Clark at the time of his appointment as Director of the National Gallery in 1934.

BELOW Hitler and his chief lieutenant, Hermann Goering, view a painting. Goering was indefatigable in his quest for works of art for both his own collection and also for the future 'super museum' planned for Hitler's birthplace in Linz. Countries occupied during the War would have their collections – both public and private – extensively plundered.

OPPOSITE An intensive bombardment of civilian centres was expected as soon as war was declared, so there was a full-scale programme for the evacuation of children out of the main urban areas in September 1939. However, when the bombing initially failed to materialise, many families came back to London.

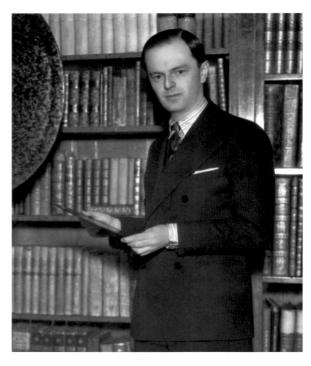

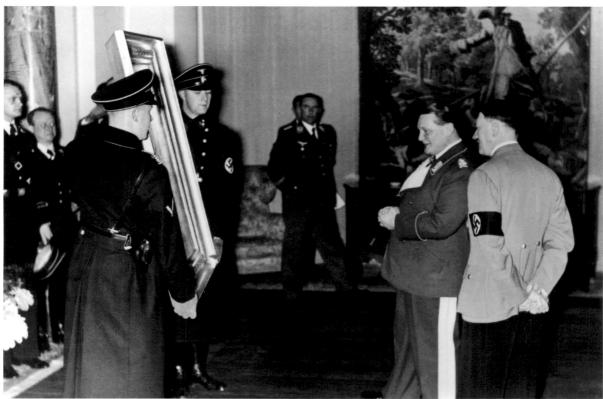

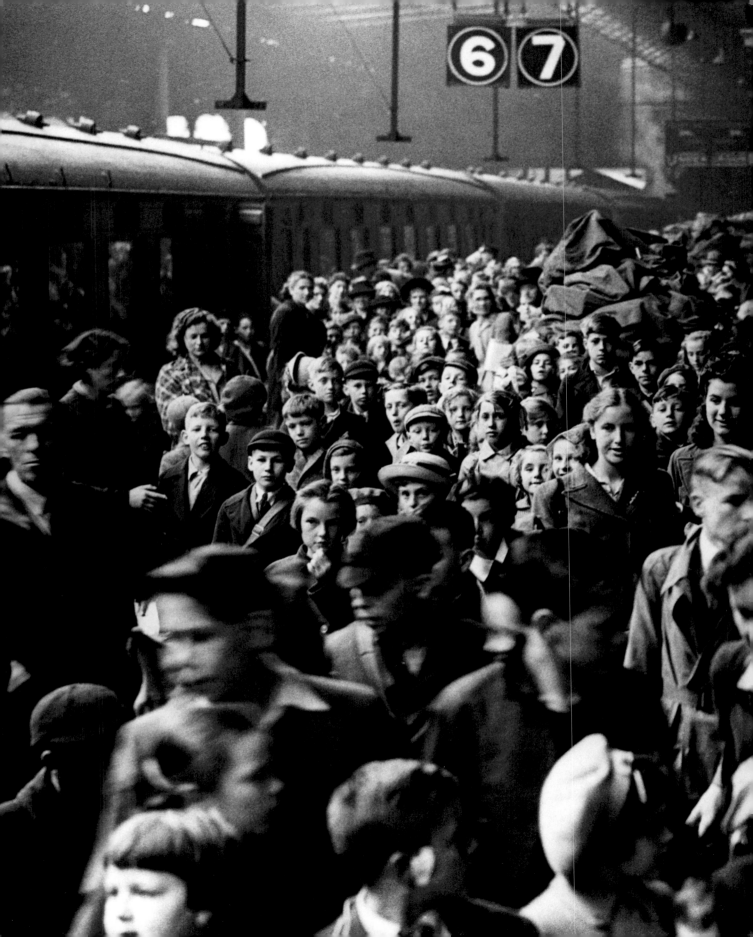

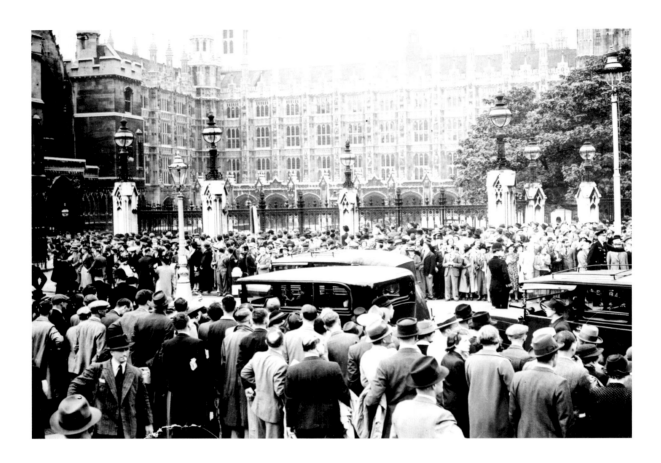

By March 1939, the remaining areas of Czechoslovakia had been swallowed up, and in August 1939 German forces invaded Poland. The intervening period between the Munich conference and the invasion of Poland had allowed British forces to be built up and defences to be prepared, but Germany's refusal to withdraw from Polish territory triggered the declaration of war on 3 September 1939.

By the time war was announced, the Gallery had been emptied of most of its treasures and the collection dispersed to many different destinations. London was on a war footing – air-raid shelters had been built, children evacuated, and gas masks issued. Sporadic air raids on military installations around the country occurred, but for many in London the war seemed remote. For months nothing seemed to happen, and the population could only wait.

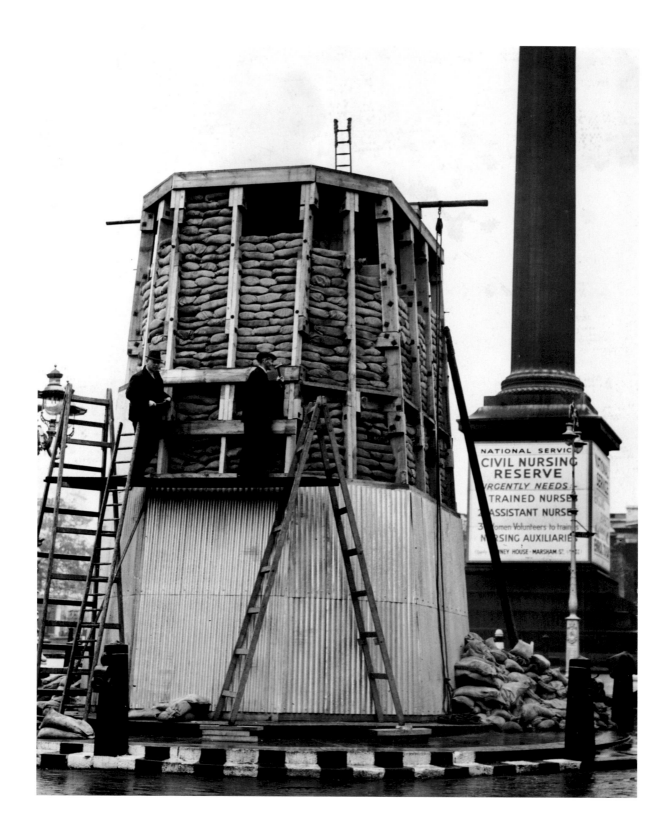

10, Downing Street,
Whitehall.

1st June, 1940.

My dear Clark,

 The Prime Minister asked me to acknowledge
the receipt of your letter of the 29th May suggesting
the evacuation from this country of certain National
Gallery pictures.

 The Prime Minister wishes me to say that he
is not prepared to agree to the evacuation of any
pictures, which he feels would be quite securely
placed if there was adequate protection for them -
if necessary, under ground.

 Yours sincerely,

 Anthony Bevir

Sir Kenneth Clark, K.C.B.

The road to Wales

On 23 August 1939 the National Gallery was open as usual – but, as soon as the doors closed behind the last visitors, a well-orchestrated evacuation plan swung into operation. War was now imminent, and the possibility that London might suffer saturation bombing meant that a new, safer home was needed for the paintings.

Over the next few days, the doors remained shut to the public while the paintings were removed from the walls and painstakingly loaded onto vehicles in conditions of strict secrecy. Vans bearing oddly shaped loads drove through the streets of London towards goods stations, where the crates were transferred to trains for their journey away from London. Some 1,800 works earmarked for evacuation had left London by 2 September, the day before war was declared.

When zeppelin raids had threatened London in the First World War, National Gallery works had been sheltered in the Aldwych tunnel of the Underground. It was recognised that more wide-ranging evacuation arrangements would be needed in the event of another war, and in 1934, owners of selected stately homes were consulted to find out if they might store the paintings in an emergency. Most of the houses were to the north-west and west of London, within relatively easy reach (including Waddesdon Manor, Stowe House, Bowood House and Buscot Park). However, in 1938, with international tensions rising, the Gallery authorities rethought the matter and a plan was drawn up for the paintings to be evacuated further afield, to Wales, where it was hoped they would be well out of harm's way.

In September 1938, during the Munich crisis, the Assistant Keeper, Martin Davies, made an exhaustive tour of country houses to assess their suitability for wartime storage. The University of North Wales at Bangor

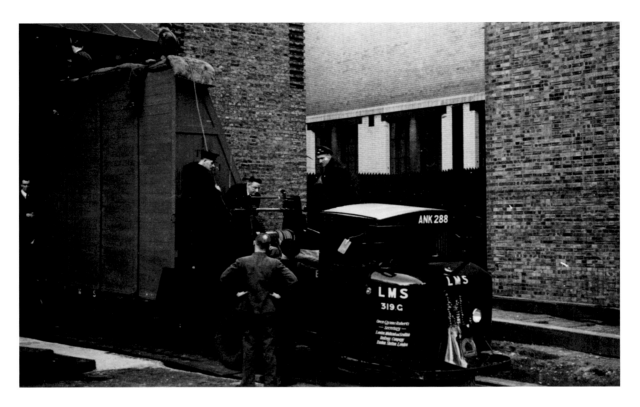

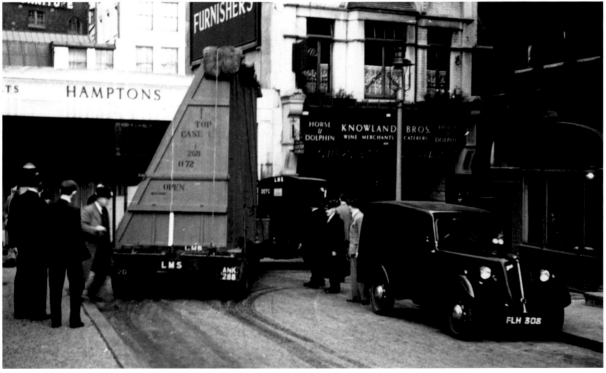

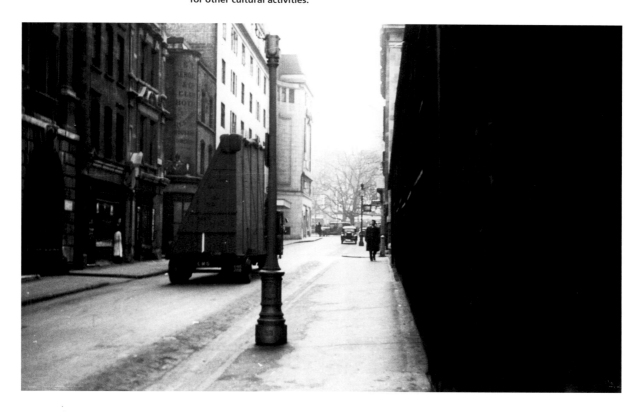

and the National Library at Aberystwyth had already been earmarked for use, but more locations were desperately needed. Davies made extensive notes on the physical statistics of the houses he visited, coupled with witheringly frank comments on some of the owners: 'The owner is nice, ruled by his wife, a tartar, anxious to have NG pictures instead of refugees or worse', and, 'Owner not inspected but seems obliging in a haughty way.' Very few houses could meet all the requirements. The pictures would have to be carried, so a minimum number of steps was essential; doorways had to be high enough to accommodate the largest paintings; and the rooms needed to be fireproof, of adequate size, with the right level of humidity. Accommodation for guards was needed as well. One house that did meet requirements was Penrhyn Castle, near Bangor. A huge neo-Norman fantasy constructed in the early nineteenth century, it had all the necessary features. Davies commented in his notebook, 'The building as a whole is extraordinarily massive.'

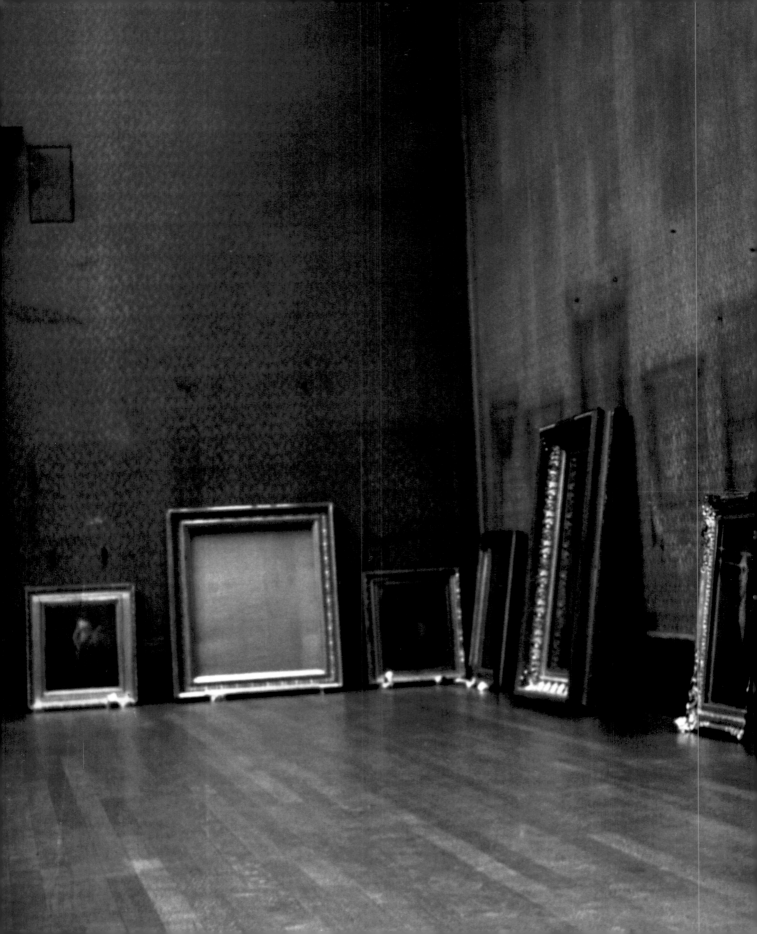

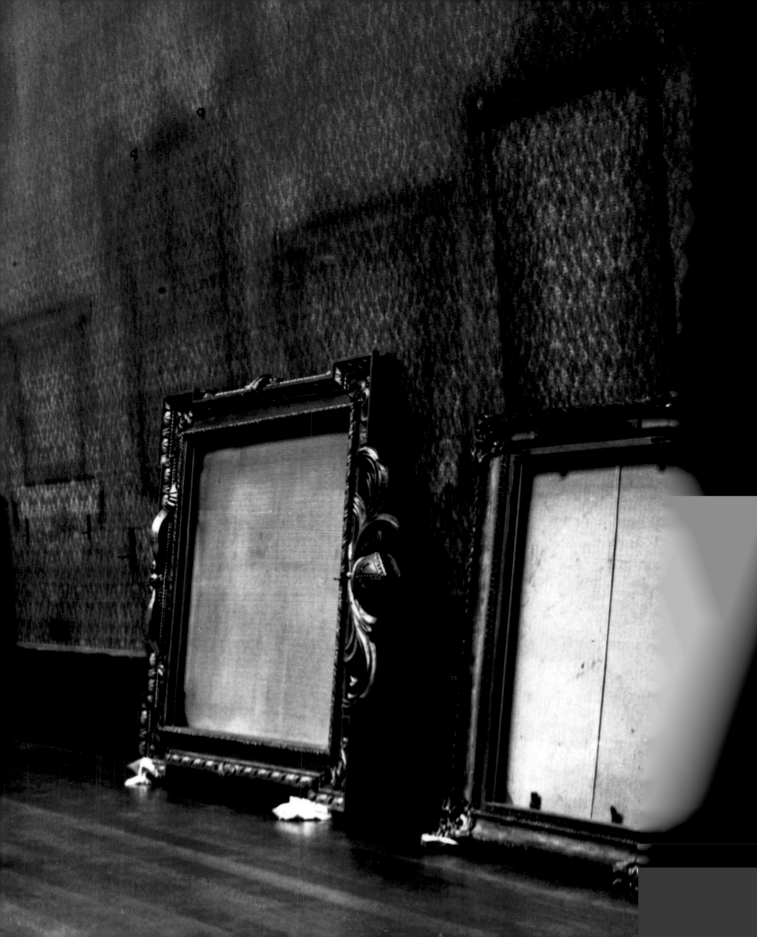

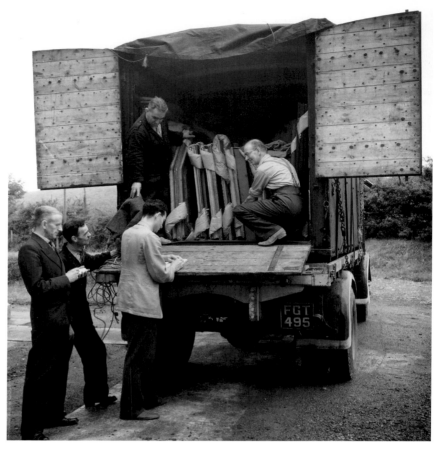

Military advisors had warned that, in the event of war, an immediate bombardment of London was a distinct possibility, and so it was decided, when negotiations at Munich seemed to be on the point of failing, to evacuate some of the paintings to Bangor. On 28 September 1938 the Gallery was partly closed for some pictures to be taken down, and the next evening two containers of paintings left for Camden goods station, where they were loaded onto specially buffered wagons, adjusted to reduce shock to a minimum. Instructions were then given to the driver, and all control points along the route were telegraphed to ensure the safe passage of the train through every station. It carried a special coded arrangement of headlamps so that it could be instantly recognised by officers of the railway company; for security reasons, most other staff were not informed about the nature of the load. The consignment arrived in Bangor at 9am on 30 September. But, even as the paintings were being transported from London, the famous Munich agreement was at last being signed: with war apparently averted, the train set off again back to London only a few hours

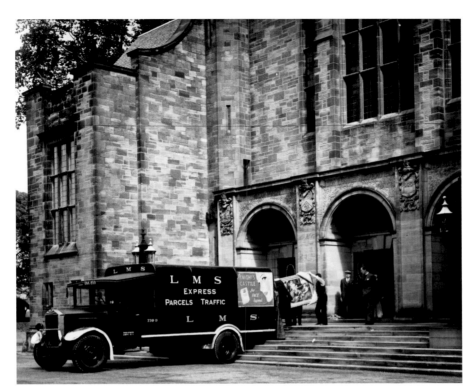

LEFT Loading a work outside Prichard Jones Hall of the University of Bangor, temporary home to a number of Gallery paintings.

BELOW The 'Elephant Case' is secured on its wagon at Penrhyn Castle for transportation. Note the garage doors on the left, where some of the pictures were stored during their temporary residence.

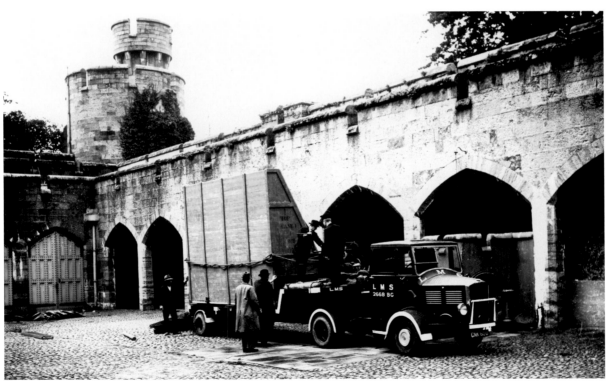

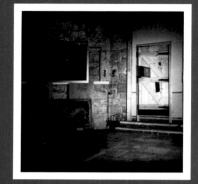

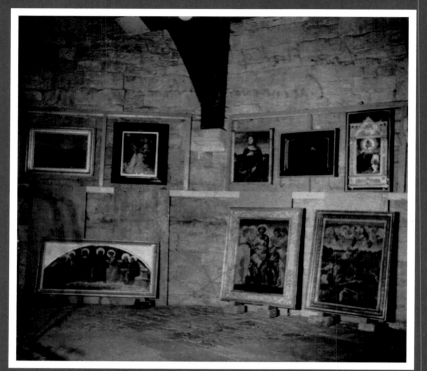

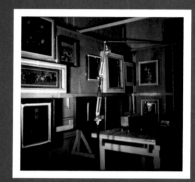

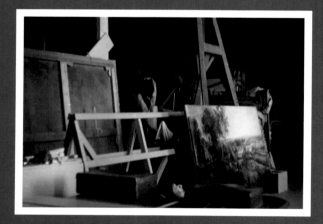

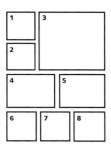

after its arrival in Bangor. Although the September 1938 evacuation of some of the paintings turned out to be unnecessary, the exercise was to be an invaluable dress rehearsal for the great migration that took place less than a year later.

In late August 1939 the majority of the National Gallery's paintings were taken to Bangor, Aberystwyth and Penrhyn Castle. Others were stored in Caernarvon Castle, Plas-yr-Bryn at Bontnewydd, and Crosswood (also known as Trawsgoed) near Aberystwyth. Some remained at Avening in Gloucestershire in the home of Lord Lee of Fareham, a trustee of the Gallery.

The many, scattered locations and their vagaries were a considerable headache for Martin Davies, who oversaw the whole operation. At Crosswood, where seventy paintings were stored, the hot-water pipes of the antiquated heating system ran under the floor of the library where the pictures were kept, seriously lowering the relative humidity, with potentially disastrous consequences for paintings on panel and canvas. As the heating could not be turned off without affecting the rest of the house, blankets and felt had to be soaked in a nearby stream and hung up in the library until the humidity reached acceptable

levels. At Penrhyn, the paintings were housed all over the castle (the locations are listed in Davies's notes as 'Main Garage', 'Paintings Garage', 'Dining Room' and 'Small Garage'), and the owner was a hazard in himself. In a letter to the Keeper, William Gibson, in London, Davies confided: 'For your most secret ear, one of our troubles at Penrhyn Castle is that the owner is celebrating the war by being fairly constantly drunk. He stumbled with a dog into the Dining Room a few days ago; this will not happen again. Yesterday, he smashed up his car, and, I believe, himself a little – so perhaps the problem has solved itself for the moment.'

When not dealing with drunken owners, Davies had to contend with over-zealous military personnel, keen to commandeer the buildings occupied by the Gallery's paintings. At Caernarvon Castle there was a proposal to use the Eagle Tower (where many of the paintings were kept) as an observation post for the Aviation Ministry, thus making it a military target. 'Some military gentleman met me in Caernarvon Castle yesterday proposing to turn the Castle into a place of defence when the Germans land at Caernarvon… If the military do turn the Castle into a place of defence we should have to consider leaving it.'

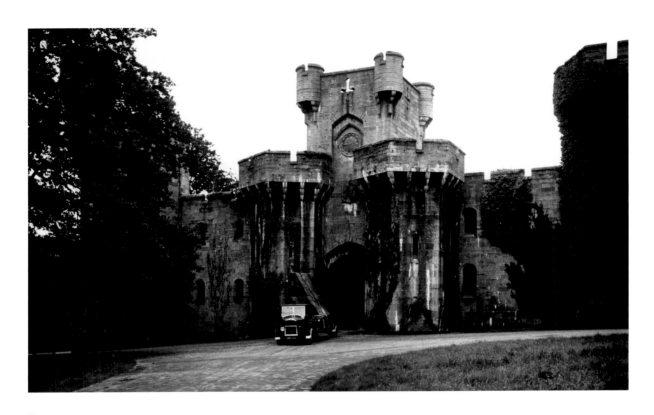

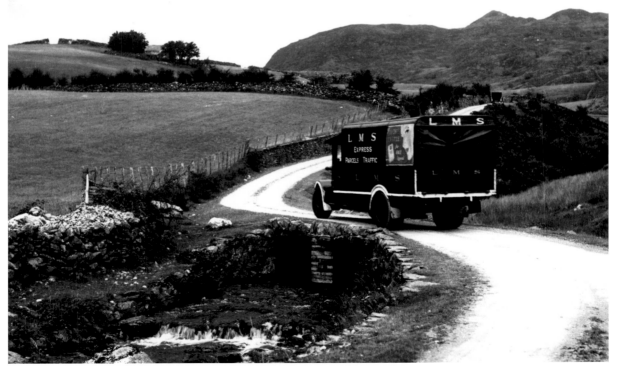

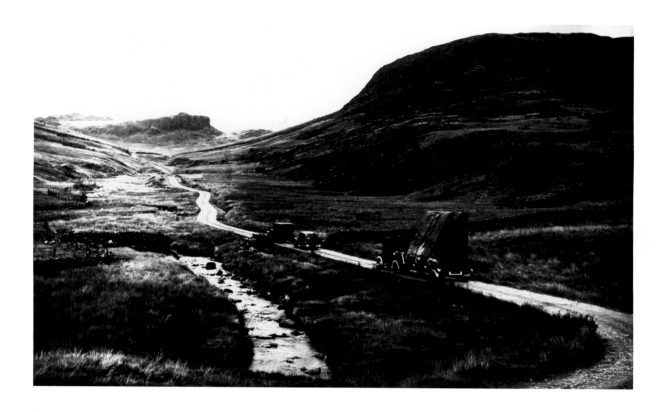

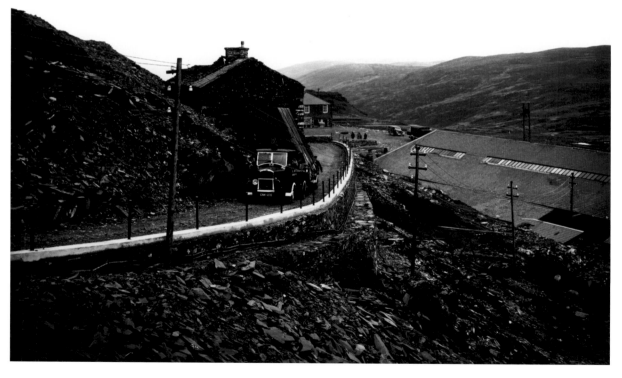

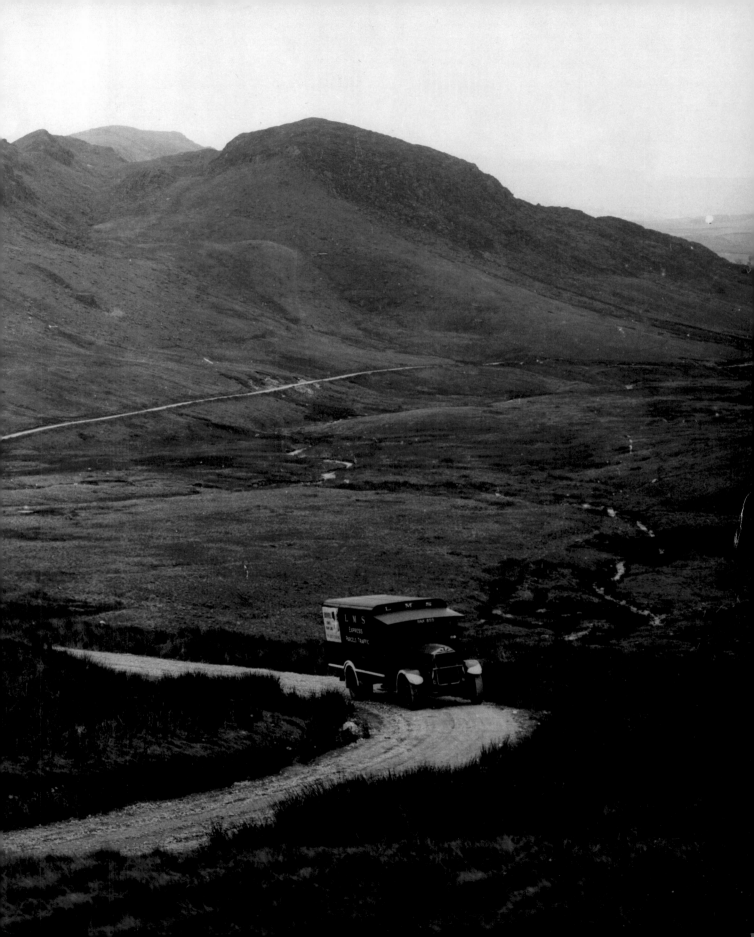

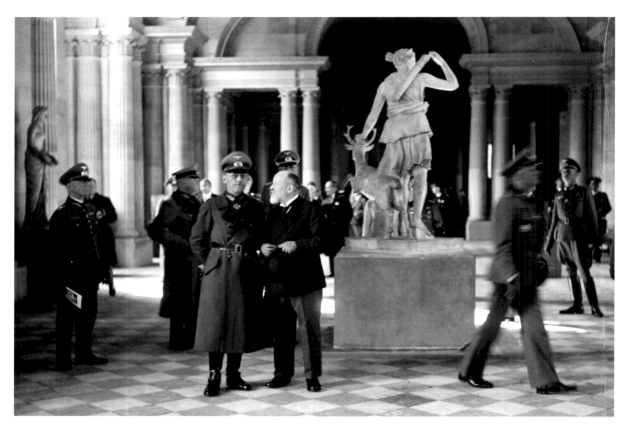

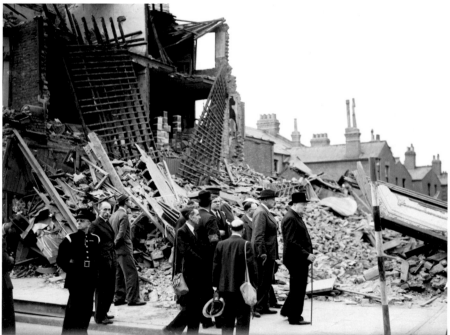

ABOVE Field Marshal Gerd
von Rundstedt of the German
army in the halls of the Louvre
at the museum's reopening
in October 1940.

LEFT Winston Churchill
(at front of group) visits
bombed-out buildings in
the East End of London
on 8 September 1940.

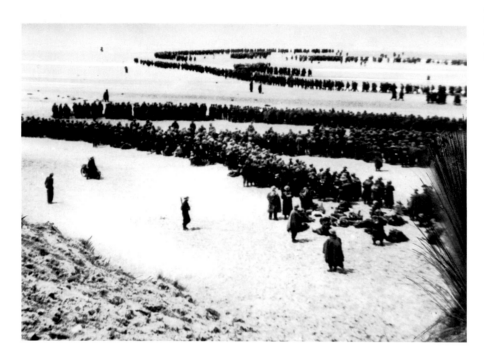

When the paintings were first evacuated from London, it had seemed that Wales would be far enough from the action to protect them. In spring 1940, however, German forces advanced through Belgium, Holland and France at a pace that shocked everyone. The British Expeditionary Force, then in northern France, retreated to the coast and was stranded on the beaches of Dunkirk. In June 1940 France fell, and in Paris German troops marched down the Champs Elysées. Hitler now turned his attention towards England.

With invasion threatening, further measures needed to be taken. Indeed, there was strong pressure from many quarters for the collection to be evacuated to Canada.

Kenneth Clark was unhappy with that proposal and, given the number of ships being torpedoed in the Atlantic, his fears were well founded. Nonetheless, plans were made in May 1940 to send the paintings out of the country. At the behest of the trustees and others, Clark raised the matter with Churchill, who firmly rejected the idea. In a letter to a colleague, Clark wrote, 'It is a load off my mind. The Prime Minister's actual words were "Hide them in caves and cellars, but not one picture shall leave this island." Will you please inform Davies. The rest of the dispersal scheme can continue.' A letter of 1 June from Downing Street confirmed the decision: 'The Prime Minister

BELOW German troops march down the Champs-Elysées in Paris on 14 June 1940. Eight days later an armistice was signed between France and Germany. On 18 June, Churchill announced, 'What General Weygand called the Battle of France is over. I expect the Battle of Britain is about to begin...'.

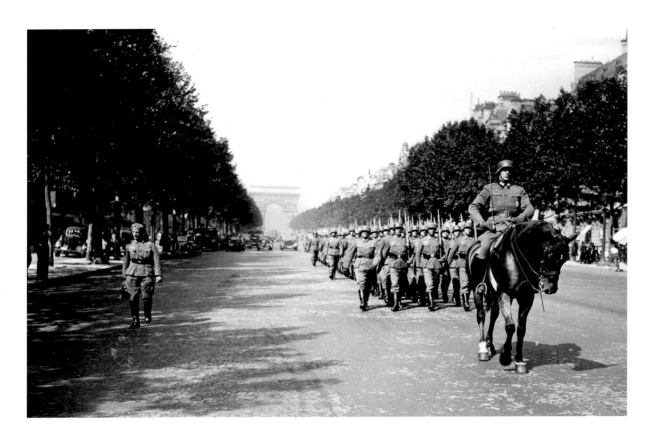

wishes me to say that he is not prepared to agree to the evacuation of any pictures, which he feels would be quite securely placed if there was adequate protection for them – if necessary, under ground.'

In the summer of 1940, the greater intensity of the bombings across Britain meant that the National Gallery Collection had to find a more secure home. The structures at Bangor, Aberystwyth, Caernarvon and Penrhyn were major landmarks, not far from the flight path of the increasing number of German bombers on their way to attack the Liverpool docks. In addition, some of these buildings were about to be requisitioned for military use, so they could no longer accommodate the paintings. The time had come to bury them 'in caves and cellars'.

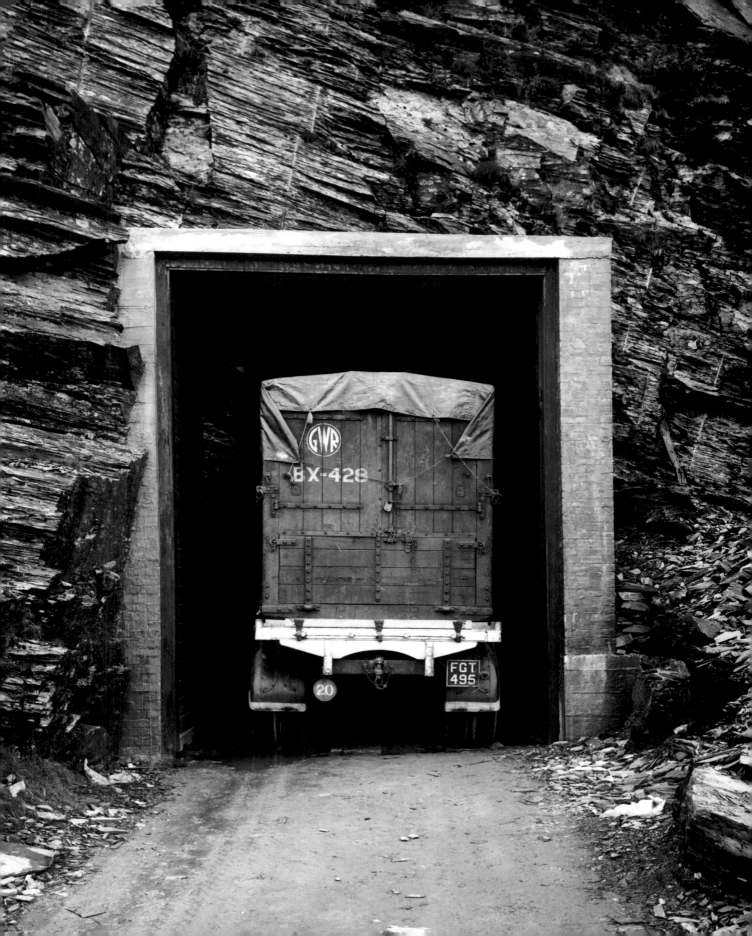

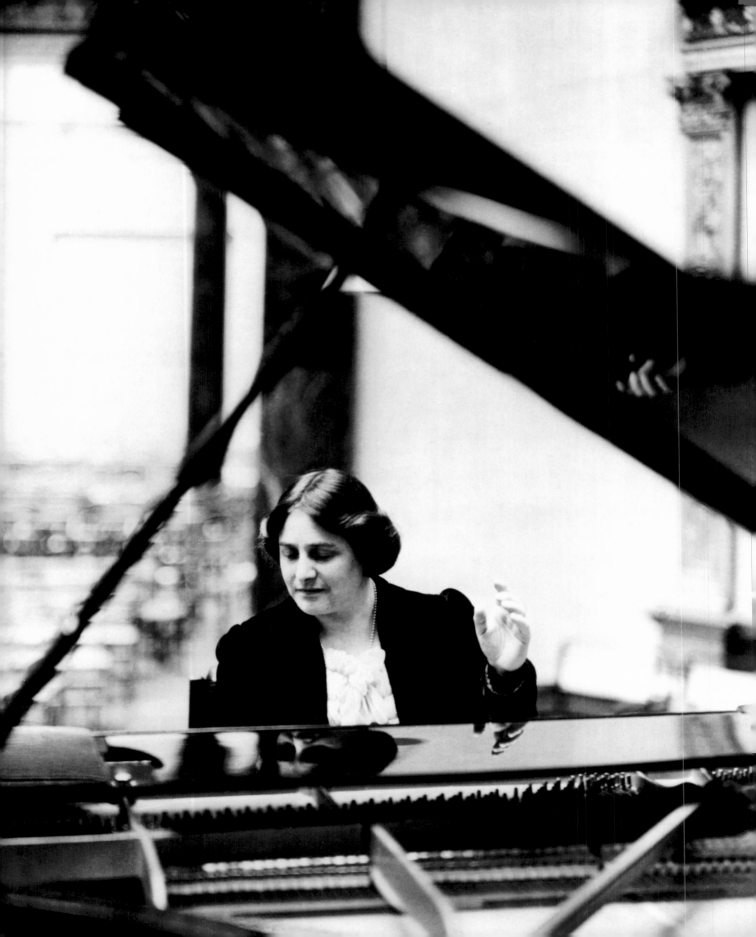

The Myra Hess concerts

When war was declared on 3 September 1939, emergency orders required all theatres, galleries and cinemas to close down. Once the paintings had departed to their safe havens in Wales, the National Gallery lay empty, and, because of its proximity to Whitehall, was earmarked for governmental use. An unexpected visitor at Kenneth Clark's office in those early September days changed everything.

With an already considerable international concert career to her name, the pianist Myra Hess viewed the outbreak of war and its accompanying restrictions with dismay. Prompted by the closure of all the cultural establishments in London, she felt 'something must be done' to uphold the morale and musical needs of fellow Londoners. A friend suggested holding special lunchtime concerts. But where, they mused? 'How about at the National Gallery?' suggested the friend. 'How about St Paul's, or even Buckingham Palace?' Hess replied, showing how unlikely she felt it was to happen. Nevertheless, they arranged a meeting with Kenneth Clark and suggested the occasional lunchtime concert. 'I said she must not give a single concert in the Gallery,' Clark recalled. 'She must give one every day. She recovered rapidly from the shock, and said it could be done.' Despite the rule under the emergency measures that no gathering of more than two hundred people could meet, the Home Office was remarkably sanguine about the proposals and the concerts were organised in record time, with the first scheduled for 10 October.

At the outset, no one knew how the concerts would be received, and Myra Hess decided to give the first one herself in case the scheme was a failure. She felt she could rely on fifty friends to attend. As it turned out, long queues had formed outside the Gallery, and the first concert under the dome of the Barry Rooms was a huge success. The concerts became

OPPOSITE Myra Hess rehearsing at the Steinway grand piano in the Barry Rooms of the National Gallery, photographed by Howard Coster.

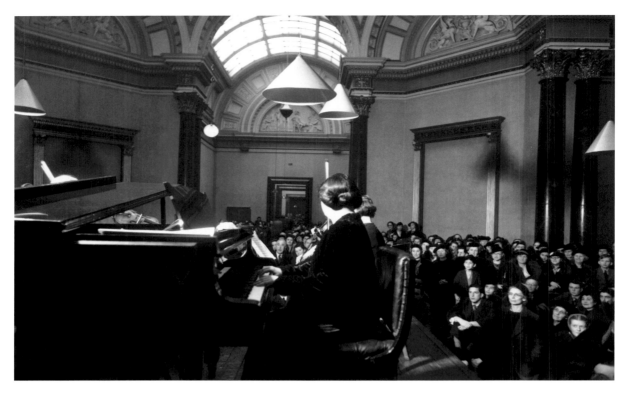

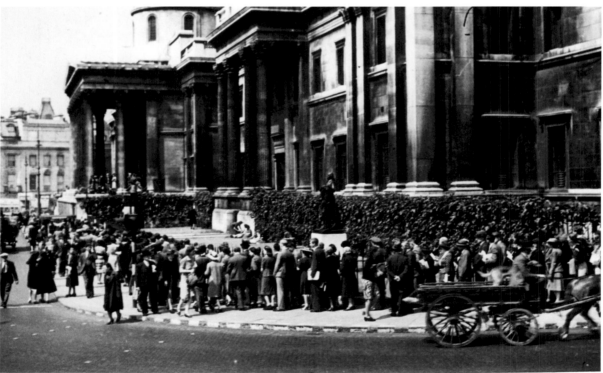

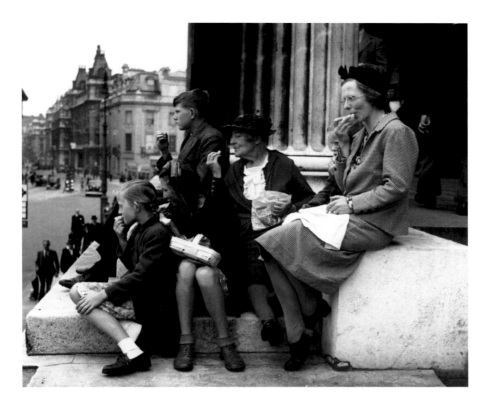

OPPOSITE ABOVE Myra Hess surveys her rapt audience from the makeshift concert platform under the dome of the Barry Rooms. The walls of the octagon are without their paintings.

OPPOSITE BELOW Crowds queuing up outside the Gallery on the day of the first lunchtime concert.

LEFT Three generations of a family enjoy a picnic beneath the portico outside the National Gallery, overlooking Trafalgar Square.

OVERLEAF A view of the exterior of the Gallery in February 1941.

a daily lunchtime event. The entrance fee was set at one shilling, with all profits going to the Musicians Benevolent Fund. Thanks to her extensive contacts in the music industry, Myra Hess was able to attract the services of many prominent musicians who all played for free or for nominal sums. The performers ranged from young musicians, many of whom were now in the armed forces, to such giants as Benjamin Britten, Kathleen Ferrier, Sir Henry Wood and Michael Tippett. Hess herself had given up a lucrative tour of the United States, where she had often performed in the years leading up to the war, and her American agent repeatedly contacted her demanding that she honour her contract. Hess tried to explain the importance of her work at the Gallery, but her agent insisted, prompting Kenneth Clark to send

the following telegram: 'Understand that you do not quite realise the importance of concerts in the National Gallery by Miss Myra Hess which have been attended by over 10,000 people including the Queen and the Chancellor, and have already become a national institution.'

Clark was an enthusiastic supporter of the concerts, which breathed cultural life back in to the building that could so easily have become another anonymous war ministry. He was unapologetic about the classical content of the programmes, and in a BBC broadcast on 24 October, a few weeks after the first concert, he said: 'I think the National Gallery concerts will be among the things that people will remember about this war, at any rate in its first phase. They were the first sign that we were recovering from a sort of

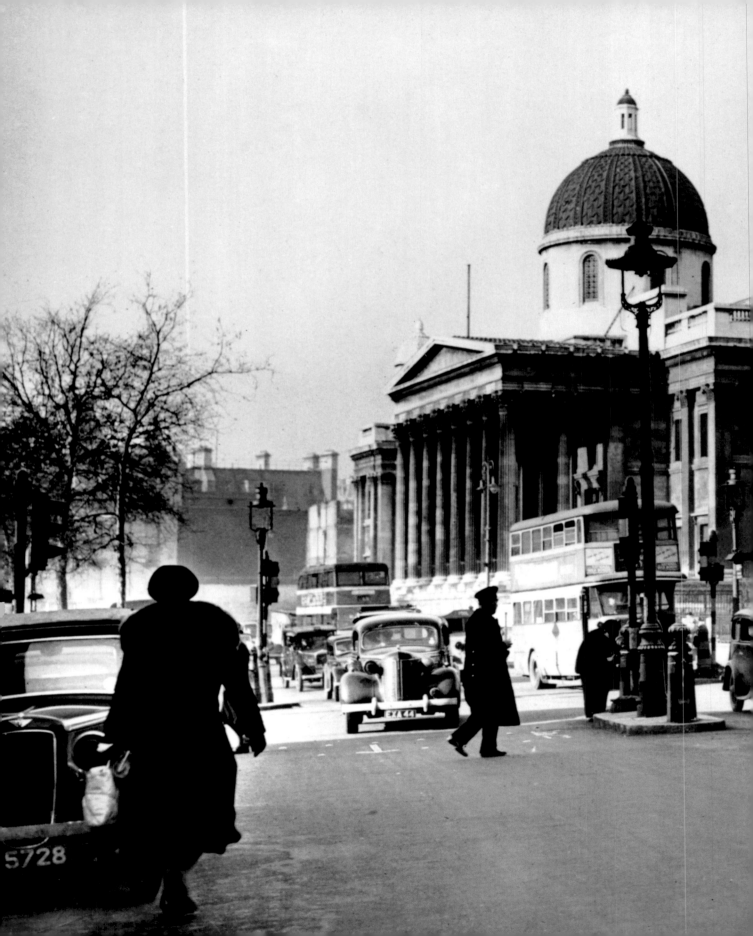

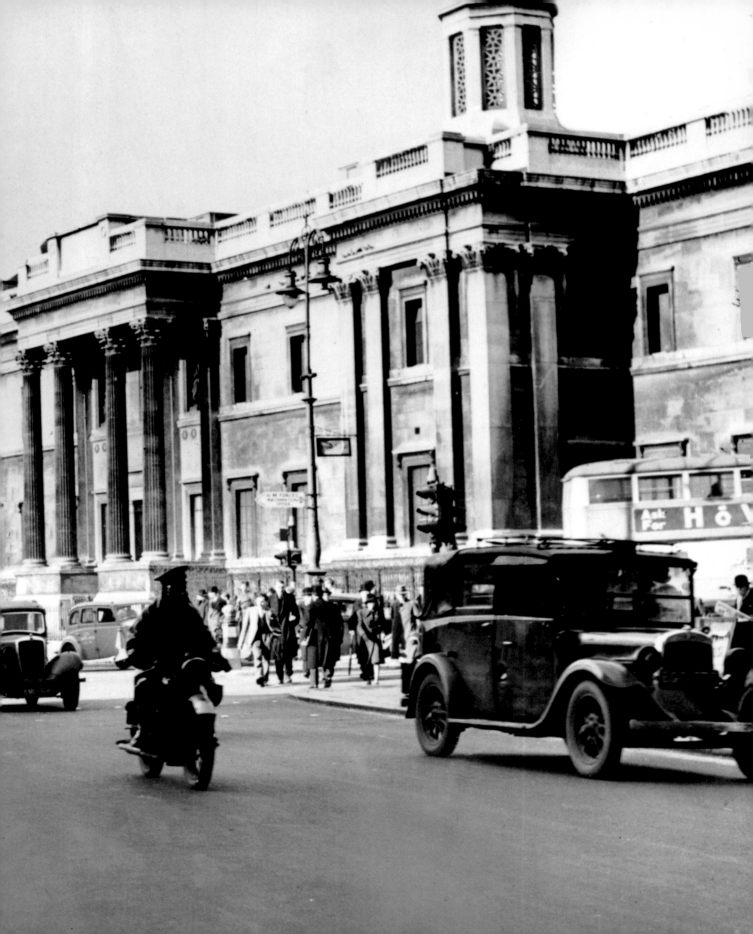

LEFT A lunchtime concert audience gathered under the portico, with the church of St Martin-in-the-Fields in the background.

RIGHT Listening to the music in the crossing of the Barry Rooms.

OPPOSITE The Blech String Quartet and Watson Forbes (viola) play a quintet for strings by Mozart under the dome of the Barry Rooms.

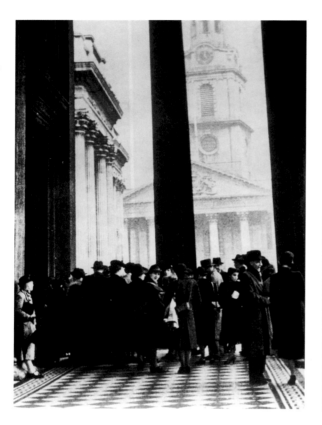

numbness which overcame our sensibilities for a week or two after war was declared; and they remain proof that although we are at war we do not want an unrelieved diet of hearty songs and patriotic imbecilities, and all the rubbish which is excused because it is supposed to be cheering us up, and which actually drives any intelligent person into a still blacker despair.' Myra Hess herself was equally uncompromising, and later remarked: 'Everybody was very busy during the war and there was nobody to tell

the people that this sort of music was over their heads. So they came and liked it.'

The concerts encountered several practical problems. In the early days, the ringing of the bells at the nearby church of St Martin-in-the-Fields was a disruption, prompting an exchange of letters between Clark and the vicar, who, to Clark's request that the bells might be silenced at the requisite time, replied: 'Very many thanks for your letter but I fear you put me in a great quandary, for not only have these

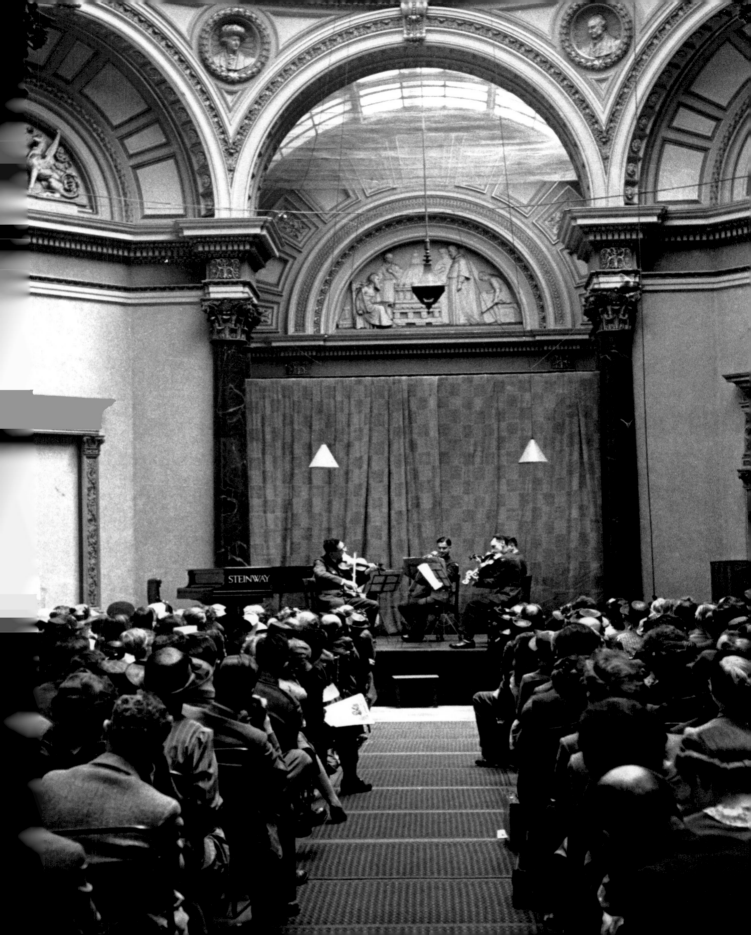

SMILING THROUGH : National Gallery Concerts

"For years I've been eating my lunch to Rembrandt, Hals, Vermeer and Hooch, so I find it a bit strange switching over to Bach, Chopin, Schubert and Brahms."

services been going on for years but it would surely be rather a pity in wartime to drop the call to people which the bells give, and as you say we cannot, of course, change the hour of our services.' The matter was soon resolved when the government ordered that all church bells should be silenced, to be rung only in the event of an invasion.

The proximity to Trafalgar Square brought its own problems – the frequent parades and fund-raising events resulted in a constant barrage of noise, often made worse by loudspeakers. Other more mundane problems presented themselves. Far exceeding the two hundred people allowed by the Home Office, concert audiences regularly ran to over a thousand, and accommodating such numbers was a logistical challenge. London was scoured for available chairs, and the minutes of a Concerts Committee meeting in 1942 record the loan of fifty chairs from Buckingham Palace.

RIGHT Members of the audience leave the Gallery after a concert.

BELOW The sandwich counter at the concerts was a great success. Joyce Grenfell recounted how, at one concert, 'We had 1,280 people and they ate 1,500 sandwiches, heaven alone knows how many dozen rolls, buns, slabs of fruit cake and chocolate biscuits. '

OPPOSITE There was a constant barrage of noise from Trafalgar Square during the concerts. Loudspeakers would often announce the latest National Savings certificates for sale, or there would be 'Warship' weeks, 'Wings for Victory' weeks, or 'Salute the Soldier' weeks, often accompanied by parades, speeches – and even the occasional plane or tank parked in the square.

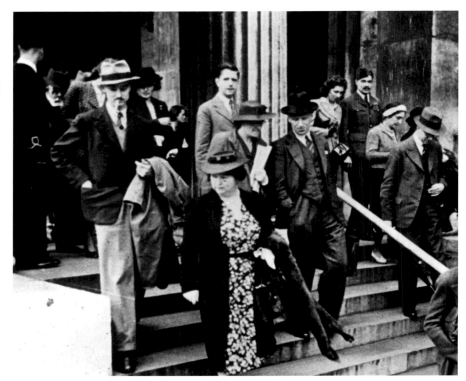

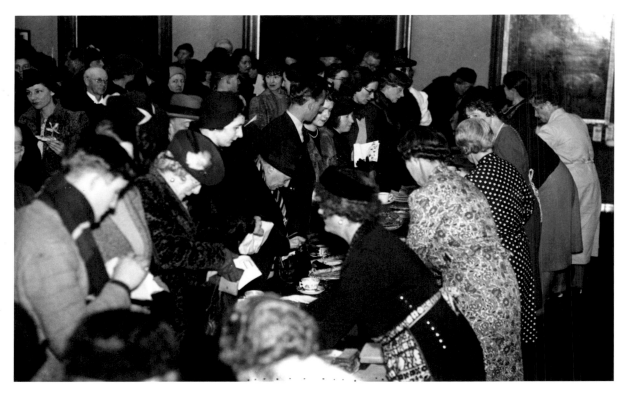

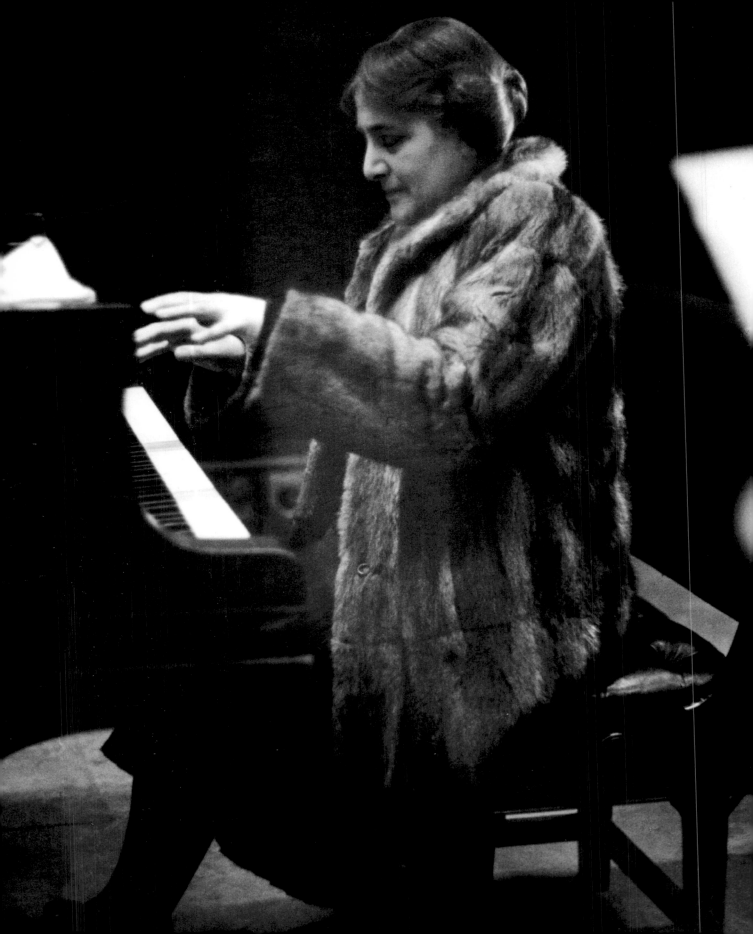

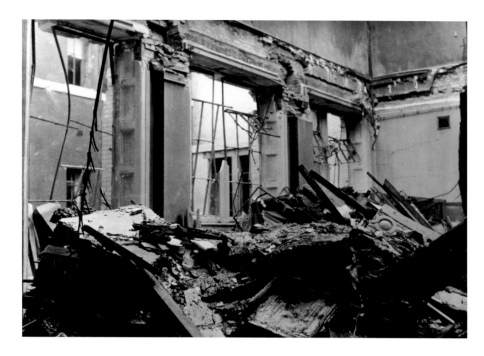

During the first year of the war, the concerts ran with little disruption, apart from the occasional air-raid alert; but when, in the late summer of 1940, the Luftwaffe switched its attacks from RAF airfields to civilian centres of population, including London, they took on a new character. The numbers attending did drop during the worst period of the raids, prompting the ever-pragmatic Hess to suggest lowering the entrance fee. The Gallery took several direct hits, but the lunchtime concerts continued without a break throughout the Blitz, moving from the Barry Rooms under the glass dome to the basement during the worst of the bombing, and only once relocating outside the Gallery to South Africa House nearby. Once, an unexploded 1,000-pound bomb, dropped the night before, was being defused in the Gallery, and the concert was moved to a room in the East Wing; the bomb exploded – fortunately while the Royal Engineers who had been working on it were taking a break for lunch. Witnesses described how the string quartet playing Beethoven barely missed a beat.

Myra Hess's own strong personality imprinted itself on the concerts. With the help of Howard Ferguson, a gifted musician and a long-time friend, she not only organised the programme performed by the other artists, but also appeared herself once or twice a week throughout the war with performances of Beethoven, Bach, Schumann and Brahms. She often played her own arrangement of Bach's 'Jesu, Joy of Man's Desiring' at the beginning or end of the programme, and for many it became indelibly associated with her. The events were broadcast on the BBC, and many who had never been to a classical concert before came to hear her play. She also appeared on

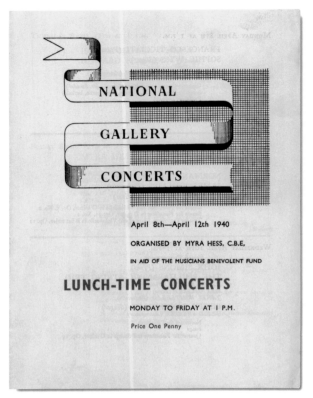

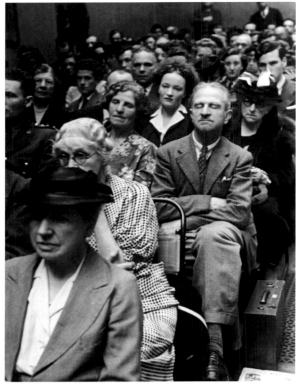

film. *Listen to Britain*, made in 1942 by Humphrey Jennings for the Central Office of Information, ostensibly for propaganda purposes, consisted of a patchwork of images illustrating the characteristic sights and sounds of Britain during the war. The final episode of the film, now regarded as a classic, showed Myra Hess playing Mozart's Piano Concerto No. 17 in G in the Barry Rooms. The Mozart was chosen by Jennings: when Myra Hess was told of the choice, she said that it wasn't in her repertoire, but – in characteristic style – she agreed that if she was given three weeks' notice of the recording session, she would have it ready for them. In addition to the Gallery concerts, she also found time to go on tour around Britain, and even gave a series of

recitals in April and May 1945 in the battle-scarred towns of the Netherlands – still technically enemy territory.

The German origin of her name caused some confusion (although born in England, she was of German-Jewish extraction). When Rudolf Hess, one of Hitler's closest advisors, landed by parachute in Scotland in 1941 on his abortive 'peace mission', Russian newspapers expressed surprise that, despite this, 'Frau Hess' was allowed to continue playing concerts all over England.

With the lessening of the air raids in mid-1941, the concerts returned to the Barry Rooms and continued until the end of the war without too much incident, apart from when 'doodlebugs' emerged in 1944. These

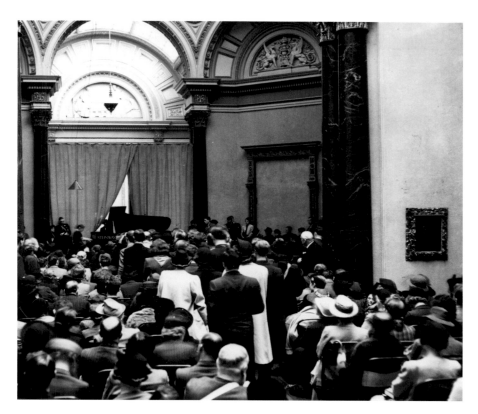

OPPOSITE LEFT Leaflet advertising the concerts illustrated with a design by the artist Barnett Freedman, a regular exhibitor at the War Artist exhibitions from 1940.

OPPOSITE RIGHT Contemporary accounts illustrated the diverse make-up of the concert audiences: young and old, men and women, military and civilian.

LEFT Standing room only: on some days, the audiences exceeded one thousand, meaning that some spectators had to stand in the aisles.

BELOW Kenneth Clark takes up the baton. On New Year's Day 1940, he conducted his one and only concert in a performance of Haydn's Toy Symphony, with Myra Hess (centre front row) performing the role of cuckoo.

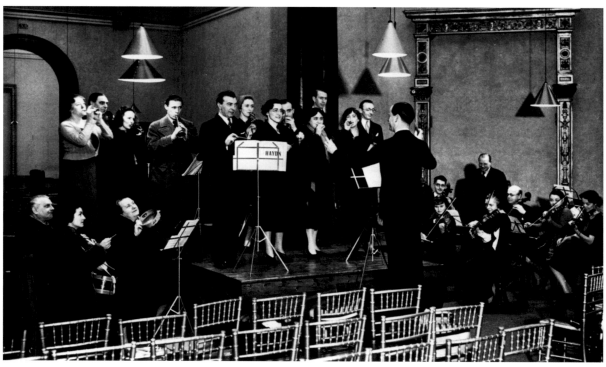

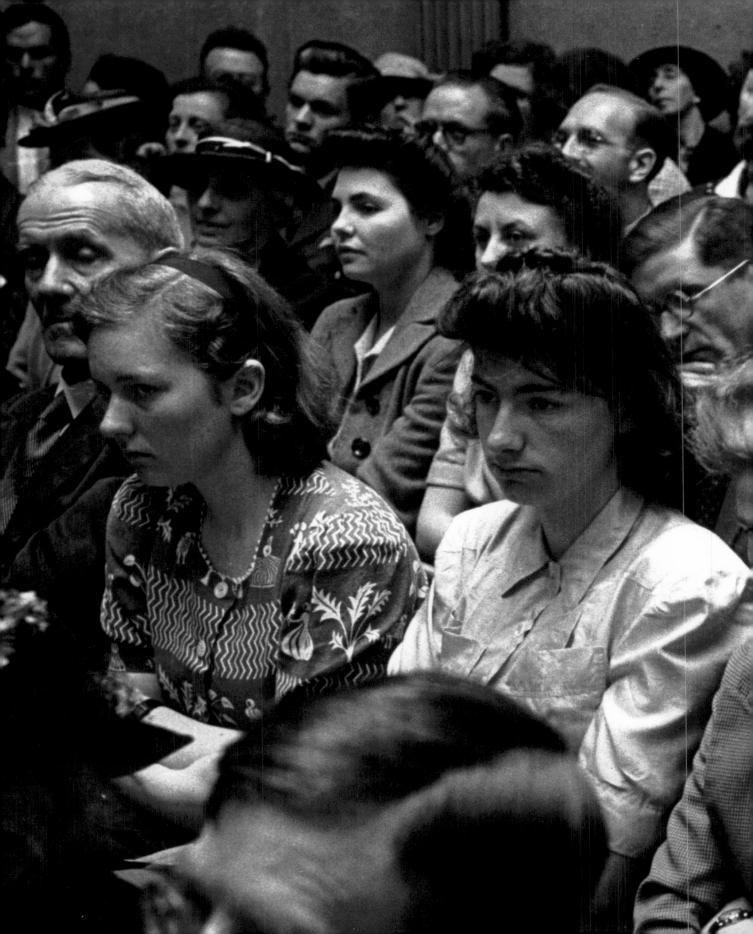

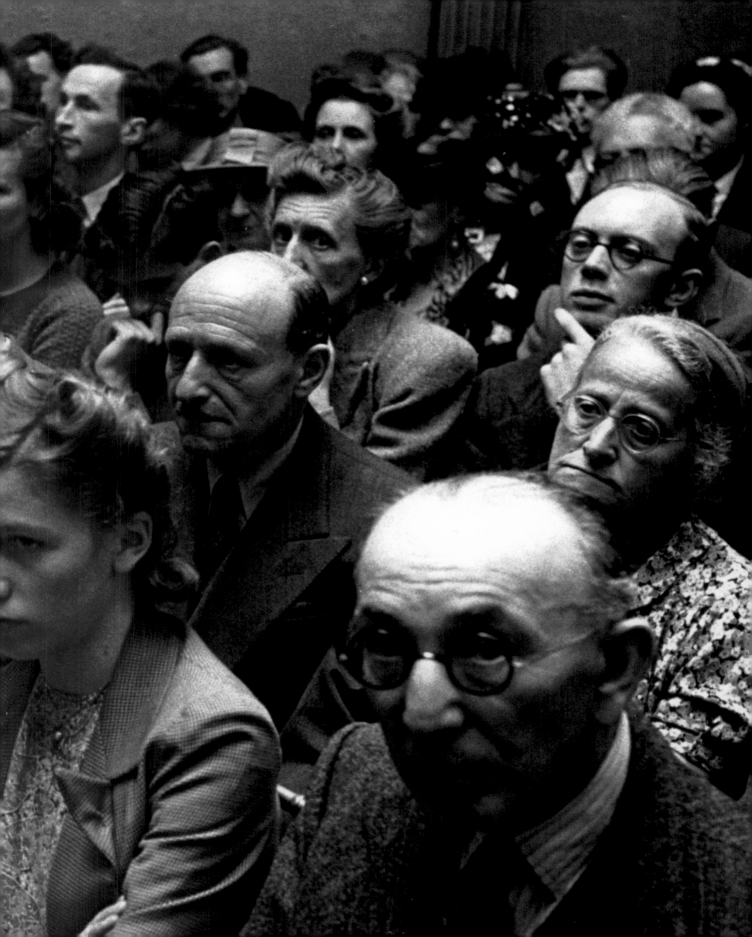

unmanned flying bombs (V–1s) containing 2,000 pounds of high explosive, caused huge destruction in London. Launched from Holland and France, the V–1s would fly until their engine cut out, and then fall wherever they happened to be. Myra Hess later recounted that, on hearing a flying bomb approaching the Gallery during her playing of one of the usually quieter variations of Schubert's Impromptu in B-flat Major Op. 142, 'I made a tremendous crescendo to cover the noise of the bomb as it flew over the Gallery, and as it passed over, an equally unauthentic diminuendo. The amusing thing was that the crescendo synchronised so completely with the horrible noise overhead that no one was conscious of what I had done.'

When the war eventually ended, the question of whether the concerts should continue became a matter of bitter division.

Given the substantial bomb damage to the Gallery, there would be little room to accommodate the returning paintings if the concerts continued. Despite many signatures to a petition in favour of their continuation, the last one took place on 10 April 1946, to a packed house. Hess later remarked, 'If I had died the day peace was declared, I would have felt my life's work was complete.' She did in fact continue her highly successful concert career in Britain and in the United States for many more years, but in the public consciousness she remained forever the person who brought music to London in the dark days of the war. On hearing a soldier whistling, 'Jesu, Joy of Man's Desiring' during a train journey, a journalist asked, 'Are you interested in Bach?' 'No,' the soldier said. 'But you're whistling a Bach composition,' the journalist persisted. 'That's not Bach,' came the reply. 'That's Myra Hess.'

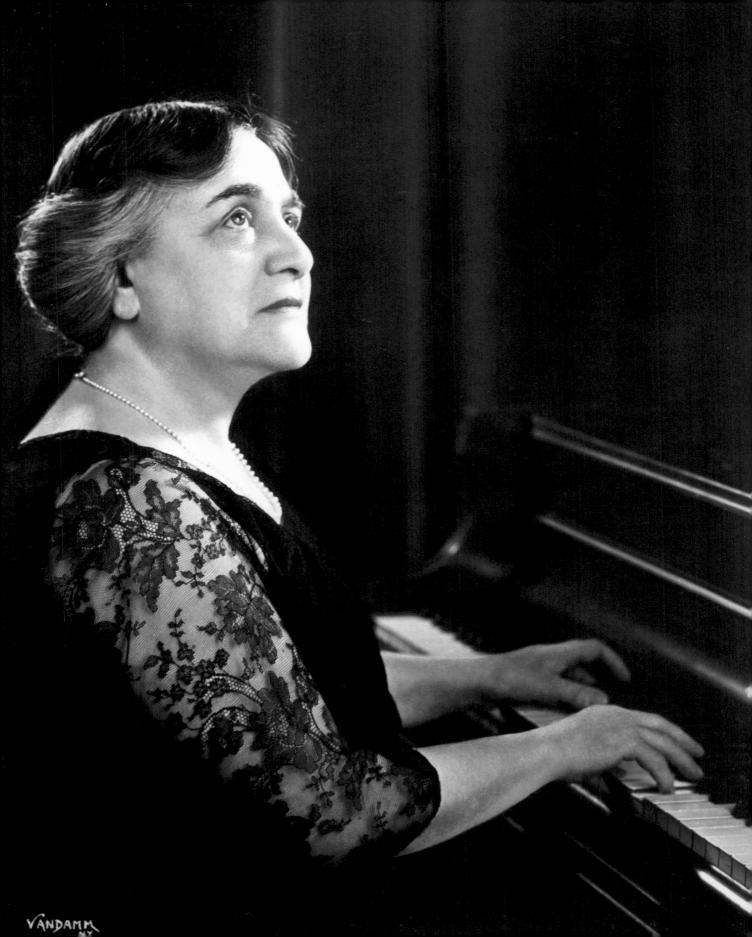

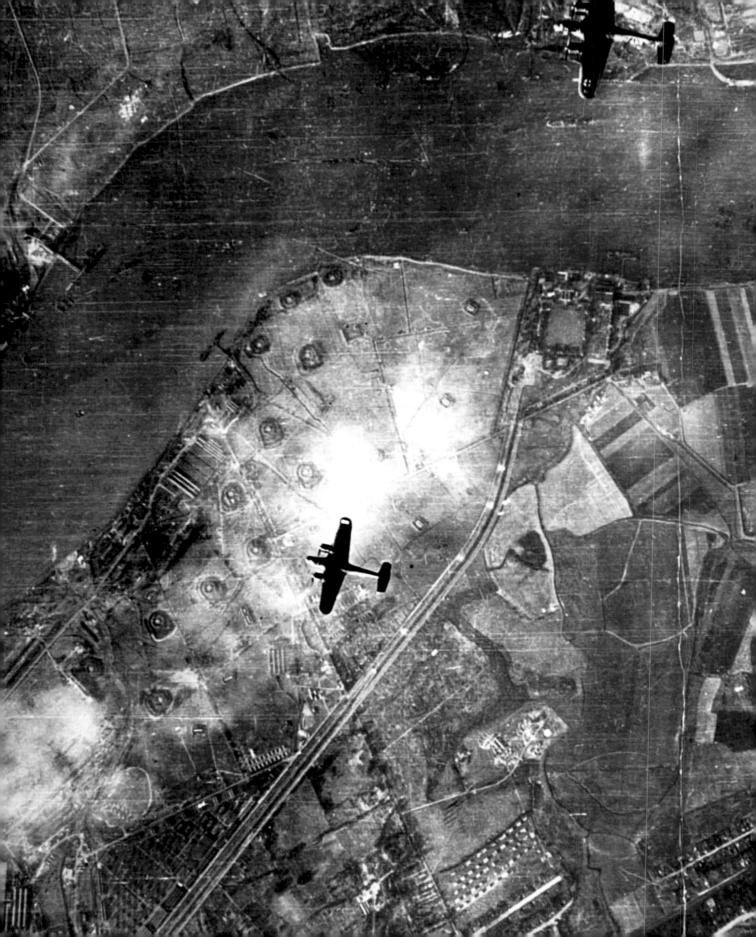

The Blitz

Barely minutes after Neville Chamberlain had finished his address to the nation on 3 September 1939, announcing that Britain was at war with Germany, London's air-raid sirens began the sinister wail that was to become so familiar over the next six years. Londoners trooped down to the shelters that had been built in the preceding months.

The declaration of war came on a Sunday at 11am, and in St Paul's Cathedral worshippers were shepherded down into the crypt. On this day, as often afterwards, the alert was a false alarm and, in the absence of the expected enemy action over the following months, the period later came to be known as the 'Phoney War'. Indeed, in London during this time, more civilian casualties were caused by the total blackout of the streets at night than by enemy action. Other towns in Britain, mainly near military installations and ports, were sporadically bombed after the outbreak of war, but London was left untouched.

With the fall of France in June 1940, however, the focus of the war moved to the south of England. The Luftwaffe concentrated its efforts on knocking out the RAF in order to leave the way open for invasion by the main German forces, and for several months the Battle of Britain raged, with airfields taking the brunt of the attacks. But when the RAF was at its weakest, the German strategy inexplicably changed, and the attacks were switched from the airfields to the docks and East End of London. On 7 September, a severe daytime bombing raid was launched on the docks, and for fifty-seven consecutive nights the centre of London was heavily bombed. This period of intensive bombing became known as 'the Blitz' and continued until May 1941, when enemy efforts were redirected towards the Soviet Union.

OPPOSITE Two German Dornier planes fly above the River Thames near Woolwich.

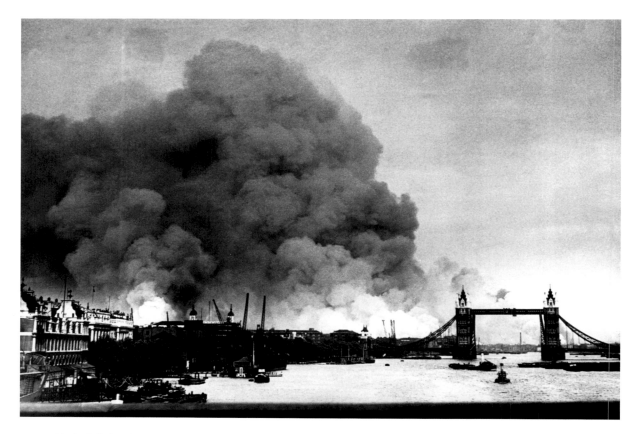

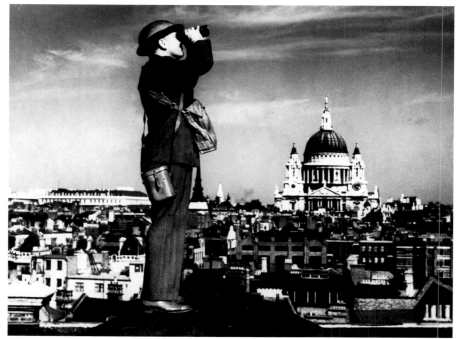

ABOVE This daylight bombing raid by the Luftwaffe on the London docks, 7 September 1940, marked the start of the London Blitz.

RIGHT A firewatcher scouring the horizon for enemy aircraft. To his east stands St Paul's Cathedral, which was to become one of the great emblems of London's survival of the Blitz. Firewatchers provided an invaluable service in spotting and disabling incendiary bombs.

OPPOSITE Londoners sheltering in the Underground in 1940. During the Blitz, whole families would congregate below ground every night, some-times even sleeping between the rails. The artist, Henry Moore, immortalised the scenes in his famous shelter sketchbooks.

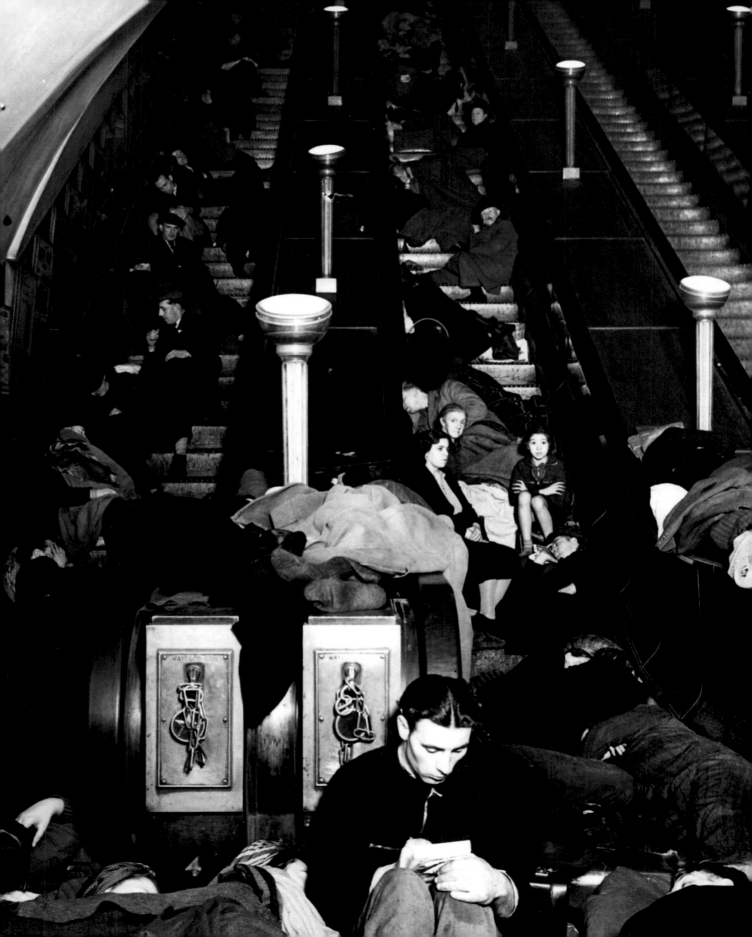

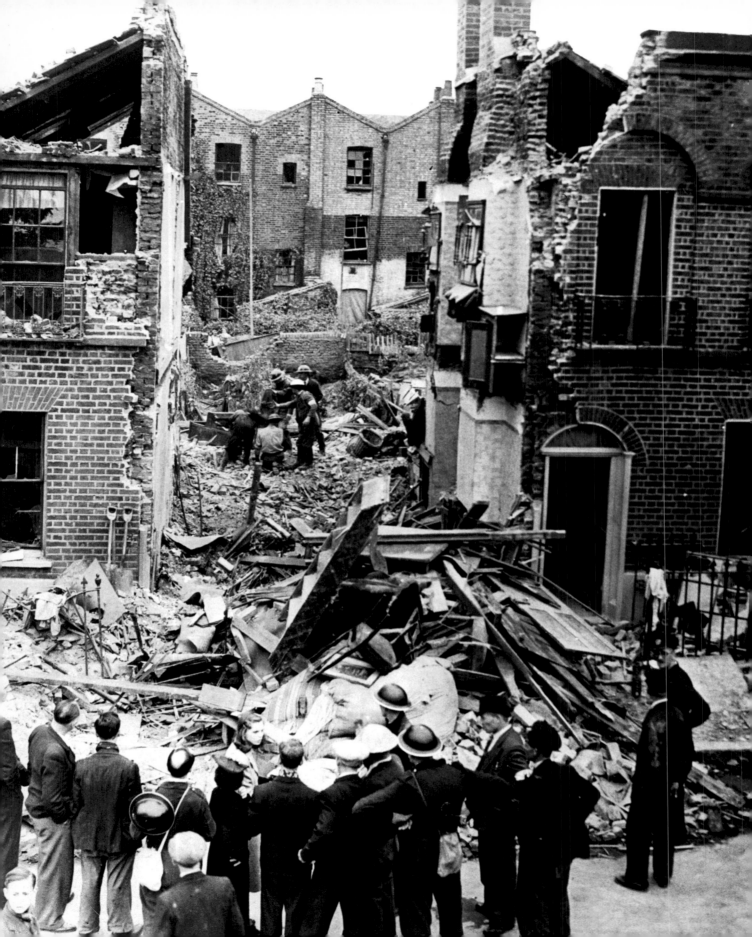

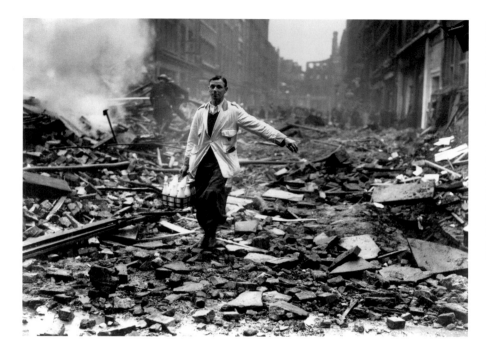

Londoners, in common with the inhabitants of other blitzed cities, became used to the strange incongruities caused by the bombing. While the famous photograph of a milkman continuing his deliveries over mounds of bombed debris was no doubt posed for the press photographers, there were equally strange sights all over the city. At night, Underground stations were full of people sleeping on the platforms and between the tracks; the fronts of houses were sheared off in bombing raids, often leaving the interior with all the furnishings untouched for everyone to see; postmen would turn up in the morning to deliver to familiar streets only to find that whole terraces had disappeared overnight; personal belongings would end up in the oddest of places. When Kenneth Clark's flat in Gray's Inn was bombed, his court regalia – tailcoat, silk stockings, knee breeches – was found completely undamaged several days later dangling from a nearby tree. The writer John Strachey described the surreal atmosphere of the time in his 1941 book *Post D*, based on his experience as an air-raid warden during the Blitz: '…the big sites, where fire had spread destruction, as at John Lewis's in Oxford Street, or at Hampton's next door to the National Gallery, were momentarily terrifying. For here was chaos: meaningless, frantic writhings of the blasted steel girders, acrid heaps of brick and stone. In the air-raid shelter of the Gallery, Myra Hess and two other musicians were playing Beethoven's Archduke Trio. The first bars struck the audience with unbearable force. The precision, the accurate, ordered, disciplined intricacy of the unrolling world of the music overwhelmed them. How could there exist such worlds as this, and as that?'

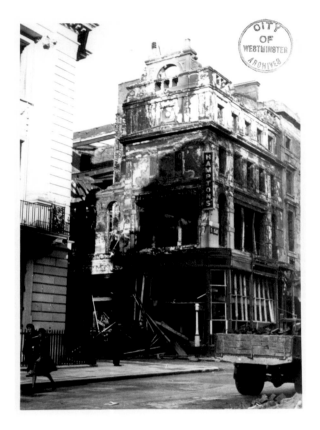

The Four Tube Railway Stations

"Trafalgar Square," "Strand," "Leicester Square" and "Piccadilly Circus" are all in the immediate neighbourhood of Pall Mall East.

The object of the plan below is to enable readers to see how near everyone of these Tube stations is to Hamptons' premises.

Hamptons
Specially invite you to view their numerous
SPECIMEN HOMES
now on view at PALL MALL EAST, S.W.1.
These exemplify many new schemes
and distinguished effects for the
WALLS + FLOORS + CEILINGS
& + DECORATIVE + LIGHTING
+ OF + ROOMS +

48

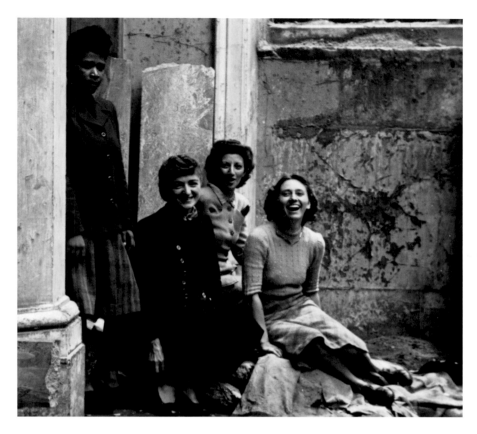

The West End did not experience the almost-total obliteration suffered by the City and East End, but the raids nevertheless caused severe damage and human casualties. The National Gallery itself – its paintings safely removed a year earlier – was to be hit nine times during the Blitz. Warders doubled up as air-raid wardens and fire-watchers during the night raids (the bombing had switched over from daytime raids, when German bombers had proved vulnerable to RAF planes). Such rooftop patrols were essential: as well as high-explosive bombs, small incendiary devices were dropped, often in a second wave, and it was these that caused many of the devastating fires that followed the raids; they could, however, be disabled relatively easily if they were spotted and quickly smothered with a bucket of sand.

On one occasion an incendiary bomb was found by warders on the roof above Room XXIV (now Room 8), and it was almost certainly similar devices that caused the total destruction, on 16 November 1940, of Hampton's furniture store, which stood next to the Gallery where the Sainsbury Wing is today – showing how easily the Gallery itself could have been destroyed. Another time, a barrage balloon collapsed on to the Gallery roof and had to be removed by the RAF (barrage balloons, flown above London to prevent attacks by low-flying aircraft, became a familiar sight).

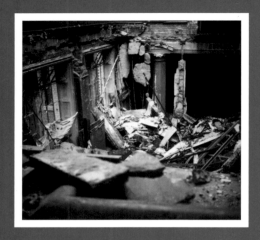
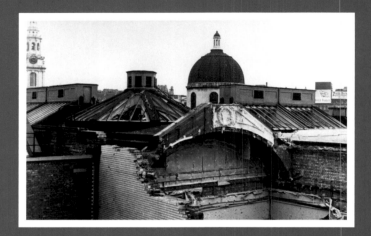
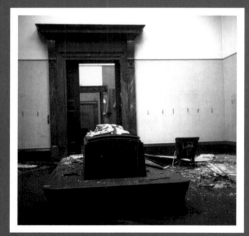
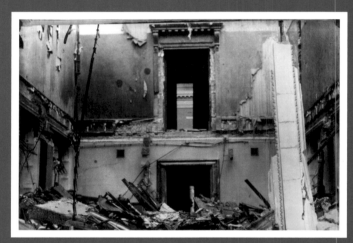
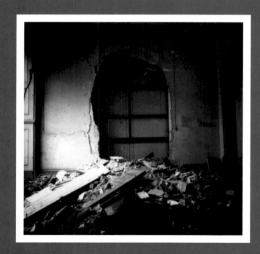
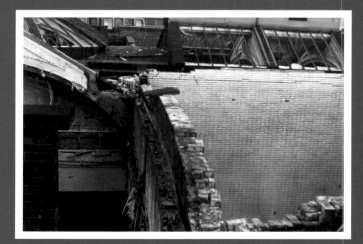

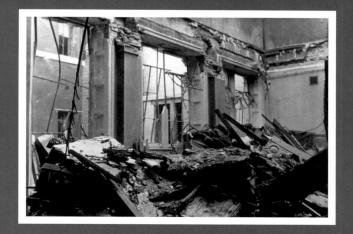

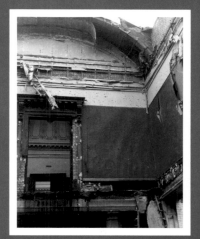

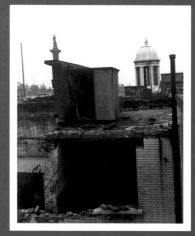

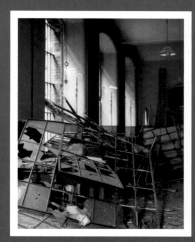

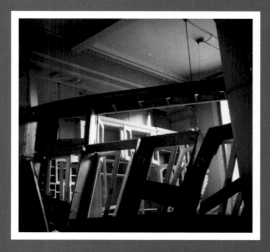

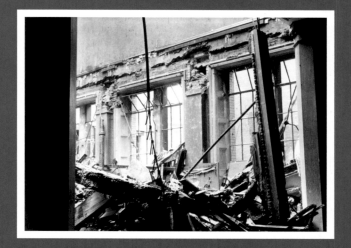

PREVIOUS Bomb damage to the National Gallery. 1 Room XXVI (now Room 10), bombed on 12 October 1940; 2 Rooftop view of the Gallery after the bomb of 12 October; 3 Room XXVIII (now Room 5); 4 General view of Room XXVI, where the Raphaels hung before the war; 5 The Old Board Room, destroyed by the explosion of a delayed-action bomb on 22 October 1940; 6 Rooftop view of bomb damage; 7 Crater caused by the bomb of 15 November 1940 in the courtyard between Rooms XI and XIV (now Rooms 35 and 43); 8 Wreckage of storeroom below Room XXVI; 9 Roof of Room XXVI, looking through to Room XXVII (now Room 11); 10 Rooftop view looking towards Nelson's Column; 11 Interior damage caused by a bomb on 16 April 1941 in the courtyard between Room VII (now Room 32) and the National Portrait Gallery; 12 View of the Library; 13 The storeroom beneath Room XXVI.

BELOW Crowds leaving a lunchtime concert on Tuesday 22 October 1940, just after the explosion of a delayed-action time bomb in the western side of the Gallery. Smoke from the explosion can be seen top left.

OPPOSITE This photograph is taken from the top of St Martin's Street, looking south from Leicester Square towards Trafalgar Square. The smoke from the explosion is clearly seen wafting from left to right. A man in the centre carries a sign 'Police – Danger'. The gap in the centre of the photograph is where the Sainsbury Wing of the Gallery stands today.

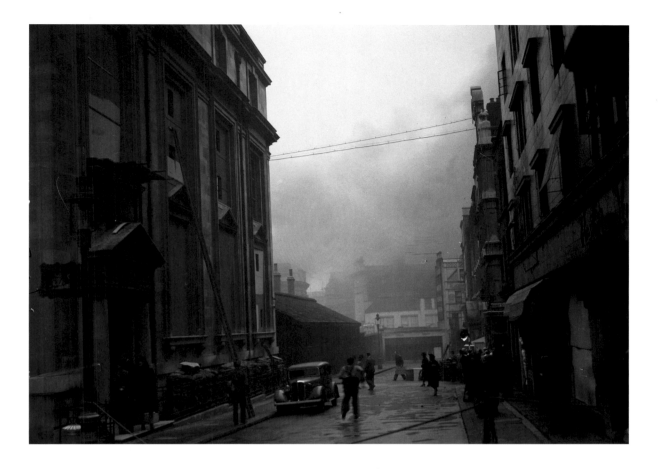

On 12 October, a large bomb fell on the Gallery, totally destroying Room XXVI (where Room 10 is situated today). Another bomb fell into a courtyard in the west part of the Gallery on 17 October, but did not explode. A team of Royal Engineers worked for days to defuse it; on 22 October, contrary to strict instructions from the Keeper, they invited some of the volunteers from the canteen to come and have a look at it. Twenty minutes after they had all gone off for lunch, the bomb exploded. It was clearly heard (and no doubt felt) by the lunchtime concert audience at the other end of the building, but the concert continued uninterrupted. Those present reported that the musicians performing a Beethoven string quartet played on regardless. The bomb caused considerable damage to the Library and destroyed the Old Board Room, but by immense good luck there were no casualties. Business continued as usual, and the warder's day diary recorded the incident in its characteristically laconic style, listing the details of the explosion with the day's usual engagements. The concerts and lectures continued. Only on one occasion was the concert relocated – on 15 October, to South Africa House – when a time bomb was found in the West Wing and Westminster City Council ordered the complete evacuation of the Gallery.

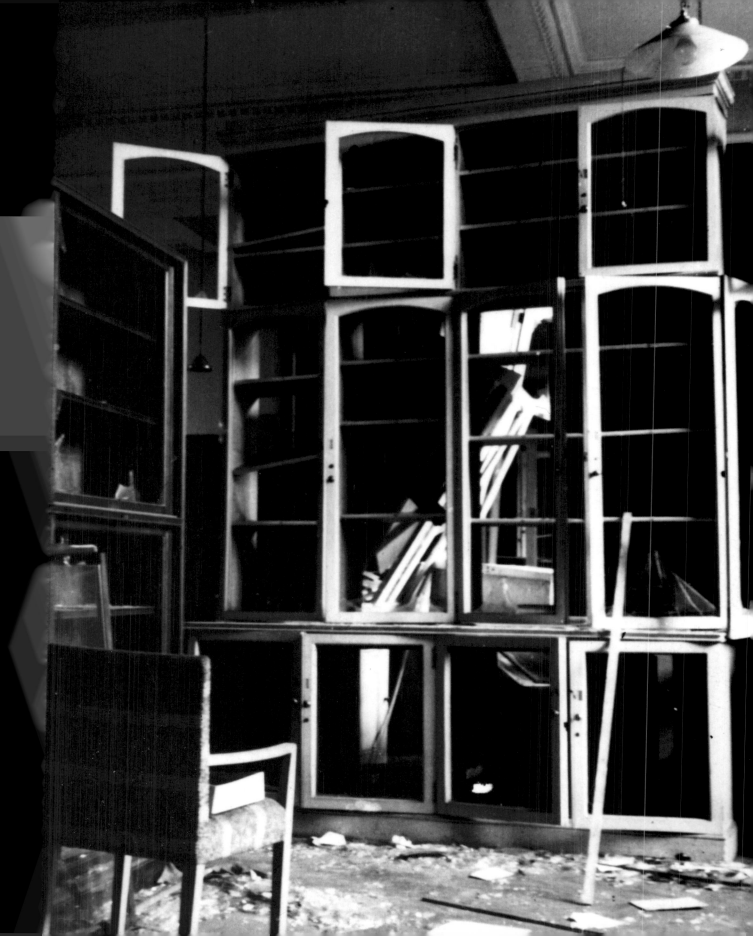

OCTOBER, 1940

Dull. Fog. Cold. Monday **21**

M.O.I. exhibition Books stacked in
rooms cleaned up. N.E. rooms

Concert 1 – 2 pm in East Wing Furniture etc looked
 out for Mr Davis

Air Raid Sirens: 10.30 am : 2.30 pm : } Some night bombing in
All clear at : 1.30 pm : 4.15 pm : } Central London Area.

Dull. Cold. Tuesday **22**

M.O.I. exhibition Books stacked in
rooms cleaned up N.E. rooms

Concert 1 – 2 pm Furniture for Mr Davis

Time bomb exploded at 1.45 pm. under old board room.
Extensive damage to building and office equipment.

Air Raid Sirens : 9.50 am : 12.45 pm : 3.15 pm : } Some bombing in
All clear at : 11.5 am : 1.30 pm : 4.20 pm : } Central London Area

Misty. Fair later. Cold Wednesday **23**

M.O.I. rooms Clearing up debris in Office
cleaned up. Rooms & corridors.

Concert 1 – 2 pm Lecture 3 pm (30)
 " 5 pm (10)

Air Raid Sirens : 8.20 am : 1.15 pm : 2.50 pm : } Night bombing
All clear at : 9.40 am : 2.30 pm : 4.45 pm : } very slight.

OPPOSITE Shattered bookcases in the Library, damaged by the delayed-action bomb explosion of 22 October 1940. Most of the Library's books had been removed from the building by this time.

LEFT A page from the warding day diary for 21 to 23 October 1940. In the entry for Tuesday 22 October (which, as the opening description indicates, was dull and cold), the words in red record: 'Time bomb exploded at 1.45pm under old board room. Extensive damage to building and office equipment'. The following day (Misty. Fair later. Cold), the diary records 'Clearing up debris in Office Rooms and corridors'. The day's usual events included a Ministry of Information exhibition, the lunchtime concert and two lectures, with air-raid alerts occurring three times during the day.

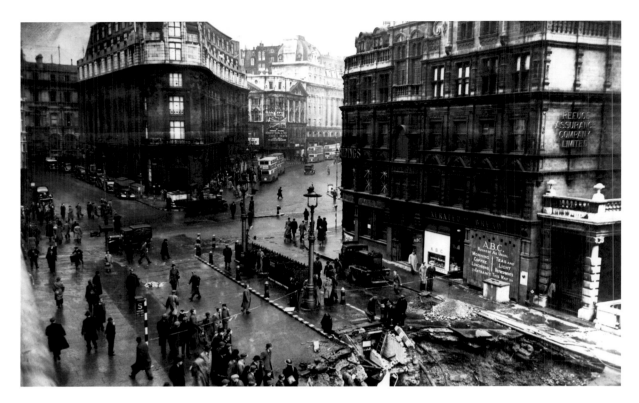

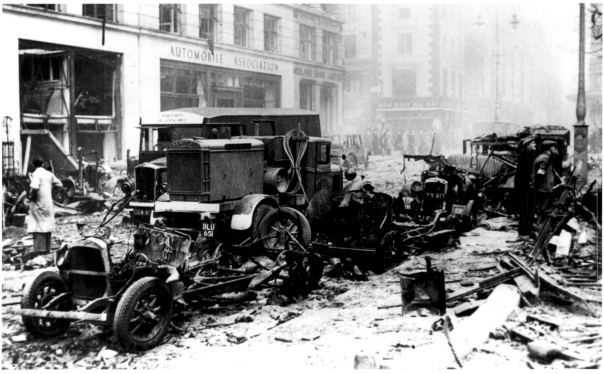

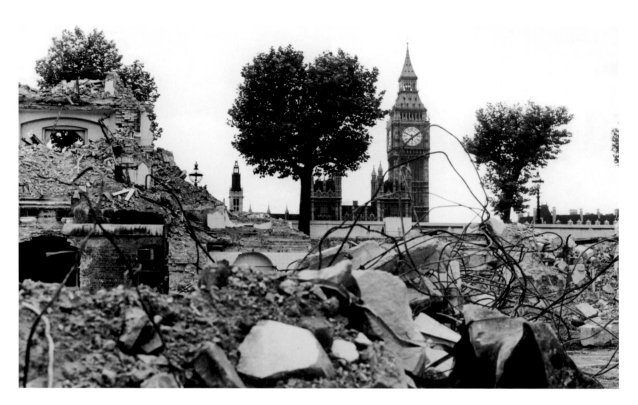

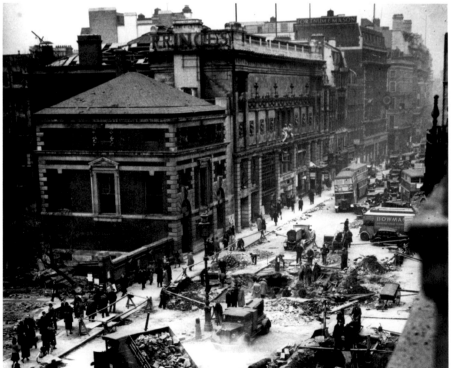

Though the centre of London was spared the almost-total obliteration of the City of London during the Blitz, bomb damage was nonetheless severe. Here, the north end of Waterloo Bridge (OPPOSITE ABOVE); Leicester Square (OPPOSITE BELOW); the South Bank opposite the Houses of Parliament (ABOVE); and Piccadilly (BELOW).

Of another occasion, Myra Hess later observed: 'I'll never forget after one of the worst raids, through which nobody slept at all, I drove to the Gallery down streets filled with debris of all kinds. Houses were demolished everywhere. 'There'll be a small audience today,' I thought. But we had an overflow house of 500 people.'

Indeed, the performers at the concerts were not immune: the pianist Kathleen Long arrived for her solo recital looking pale and dishevelled, and it transpired that she had lost her home and all her belongings in a raid the night before. She was given the option to cancel, but nevertheless gave her concert, and Myra Hess observed that she had never played better.

In human terms, the National Gallery emerged relatively unscathed, due to the fact that most of the hits occurred during the night. Exhibitions, concerts, canteen lunches and lectures went on throughout the Blitz, in a classic illustration of the phrase dear to Londoners at the time: 'Business as usual'. Other cultural institutions suffered far greater damage: the Tate Gallery on Millbank was so badly bombed that it was unable to reopen for the duration of the war, and damage to the stonework can still be clearly seen at the west entrance.

Bombing raids on London continued sporadically throughout the war, with a renewed impetus from mid-1944 with the V-1 flying bombs and V-2 rockets. However, nothing was to match the intensity of 1940–1. The Blitz on London and other British cities during that time cost 30,000 people their lives (around half being Londoners); and 1,400,000 Londoners (one in six) were made homeless at some time over the same period.

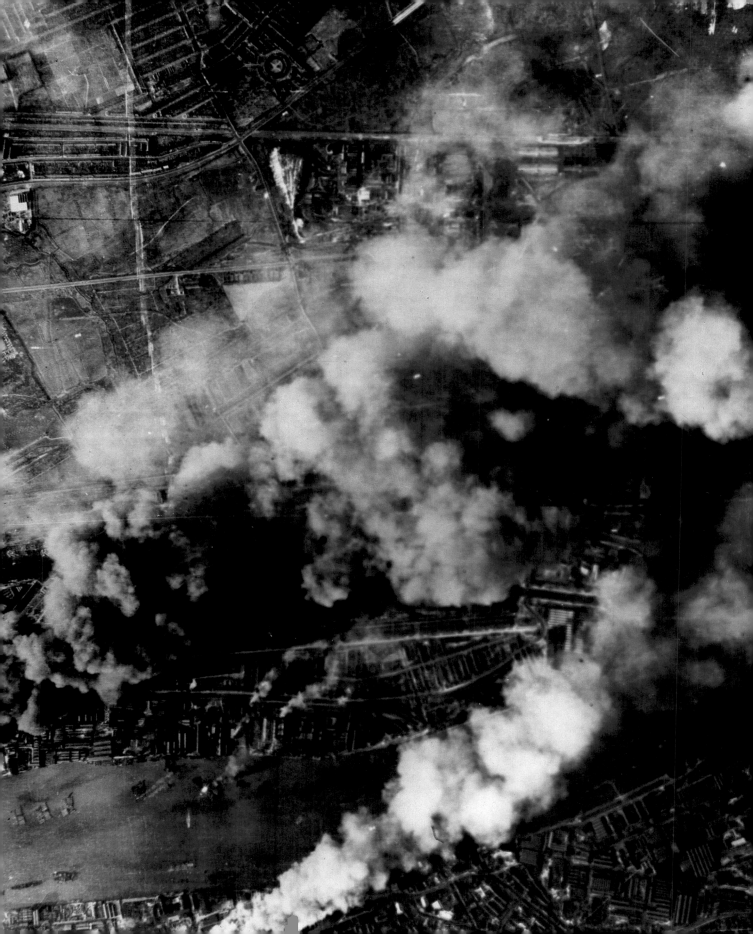

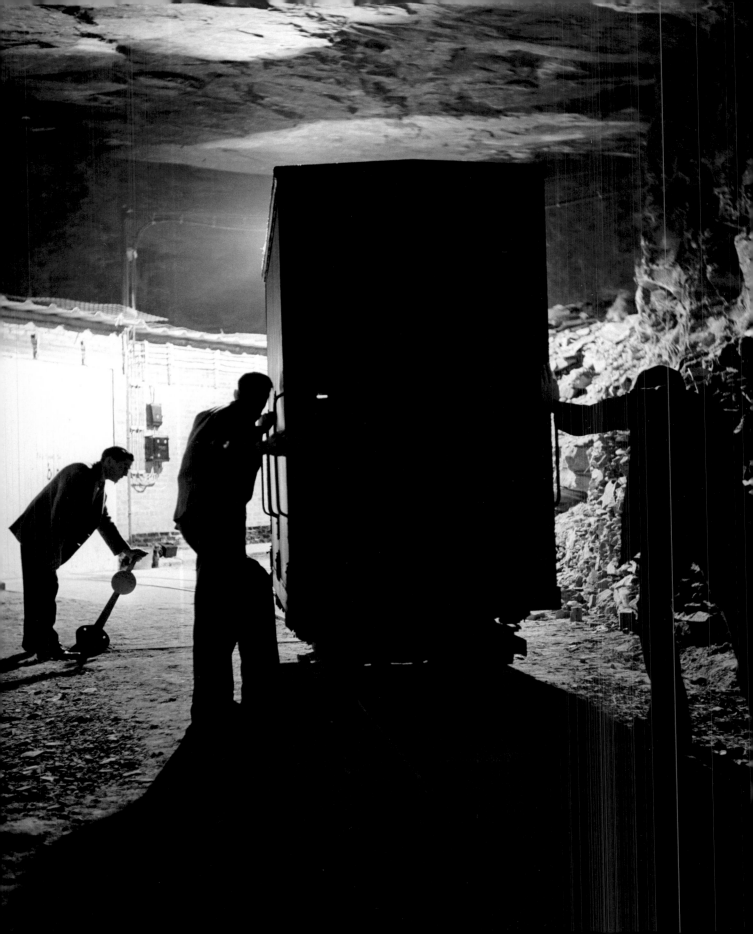

Art underground

During the summer of 1940, Martin Davies and Ian Rawlins, the Gallery's scientific advisor, set about finding a safer home for the collection. In view of the widespread bombing raids, an underground location was considered the best option. Wales had an abundance of slate quarries and mines from which to choose. After much searching, the ideal location was found at Manod quarry, not far from Blaenau Ffestiniog.

It was relatively close to the railway – a great advantage for the transport of the paintings – but also remote, at 1,700 feet above sea level, and the final stretch was only accessible via four miles of winding, mountainous road. And it was huge, with large underground chambers where the paintings were to be stored (one was named 'the Cathedral', so vast were its proportions). The quarry was found in mid-September 1940, and the Office of Works responded within a fortnight to the request for its requisition: 'Dear Clark, The Treasury, having seen our officer's report on the disused slate chambers which you propose adapting as a home for the National Gallery pictures, agree that the scheme should go ahead and we have made arrangements that the Quarry shall not be released for other purposes without further word from us.'

The considerable work needed to make Manod quarry suitable for the collection began almost immediately. Some 5,000 tons of rock had to be removed by blasting in order to make the entrance tunnel large enough for the biggest paintings. To create controlled conditions and protect the collection from the slate dust, freestanding brick buildings were erected in the underground chambers of the quarry. Narrow-gauge railway tracks were laid to facilitate the transport of works from one location to another within the quarry, and special wagons, to protect

OPPOSITE Inside the tunnels of Manod quarry, a wagon containing paintings is wheeled along specially installed railway tracks towards one of the brick huts where the works were stored.

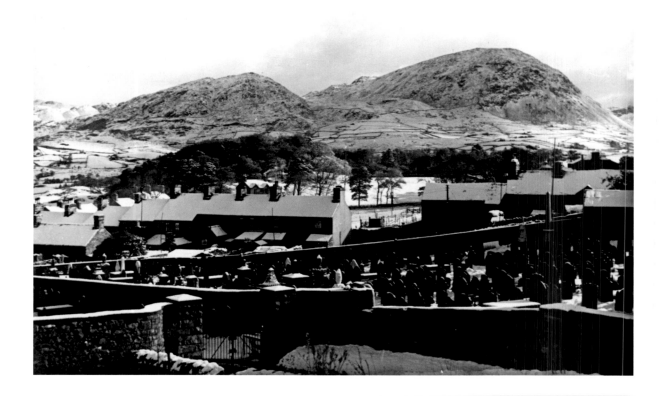

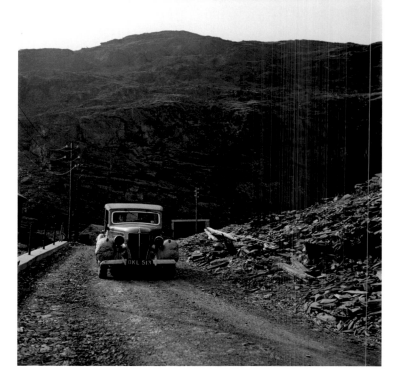

ABOVE The village of Manod with the stark outline of the quarry hills in the background.

RIGHT A car leaves the quarry, passing the slate workings and dwarfed by the craggy backdrop. The entrance to the tunnels is just visible to the right of the car.

OPPOSITE ABOVE From left to right: Ian Rawlins, C.A.Vaughan (the manager of the quarry) and Martin Davies, wearing a most eccentric hat.

OPPOSITE BELOW The entrance to container no.1 in the quarry. The railway tracks went straight into the building, so that the wagons could be unpacked inside the hut in order to protect the paintings from dust and temperature variations.

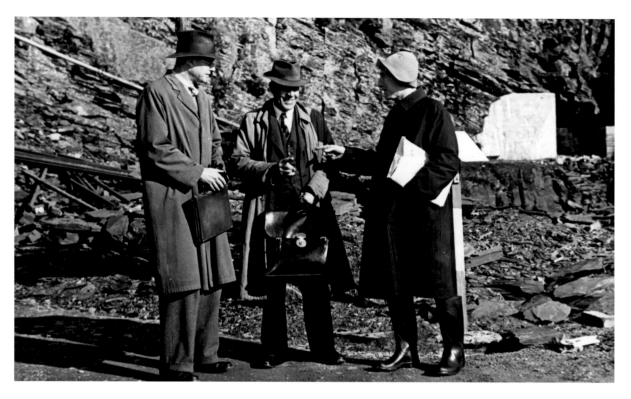

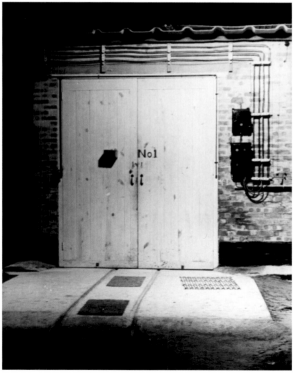

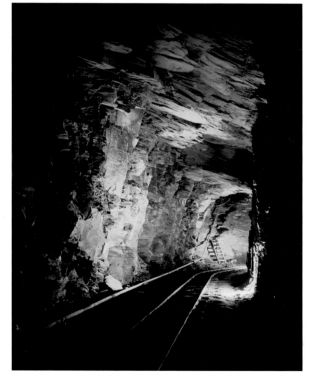

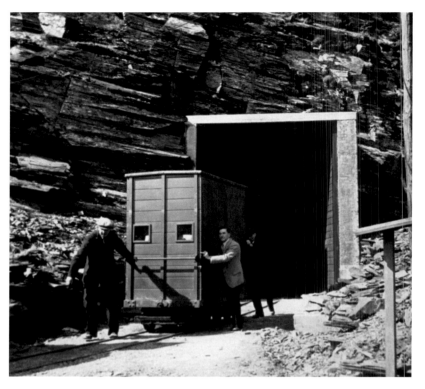

the works from variations of temperature and humidity during their transport, were built to the Gallery's designs by the London, Midland and Scottish Railway Company in Derby.

In the summer of 1941 the paintings were again loaded onto trains and vans from their various locations in Wales, to converge on the quarry. The complex operation went relatively smoothly thanks to the highly organised mind of Ian Rawlins, a railway expert who could advise on every aspect of the transportation, as he had during the speedy evacuation from London at the outbreak of war. There were problems, however: high winds on exposed parts of the route meant the bigger crates were vulnerable, and the great Van Dyck *Equestrian Portrait of Charles I* (NG 1172), one of the largest works in the collection, had to be manoeuvred

under a low railway bridge near Blaenau Ffestiniog. The road was hollowed out to allow the huge triangular crate (known as the 'Elephant Case') through, and there were several rehearsals with it empty before the actual painting was transported. On the day itself, the masterpiece made it through the arch only after a tense half-hour of manoeuvring: some accounts claim that the tyres of the truck had to be deflated.

Over a period of five weeks the whole collection, together with the library, stores and equipment, was moved to the quarry, where once again it had a single home (for reasons of space, some pictures belonging to private owners were left at Bangor and Aberystwyth). Within the brick structures, the paintings were stacked in rows so that they could be inspected

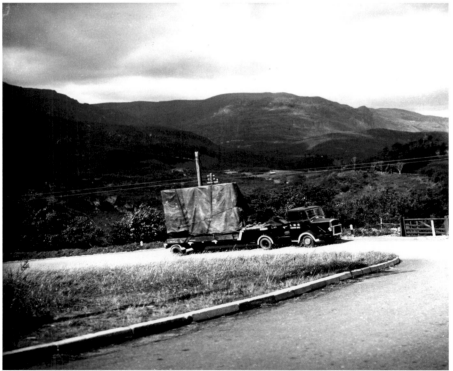

ABOVE The 'Elephant Case' under the low bridge near Blaenau Ffestiniog. Although the road was hollowed out especially for the occasion, the case did get stuck under the arch for a short time.

LEFT The 'Elephant Case' makes its way up the steep and winding approach road to Manod.

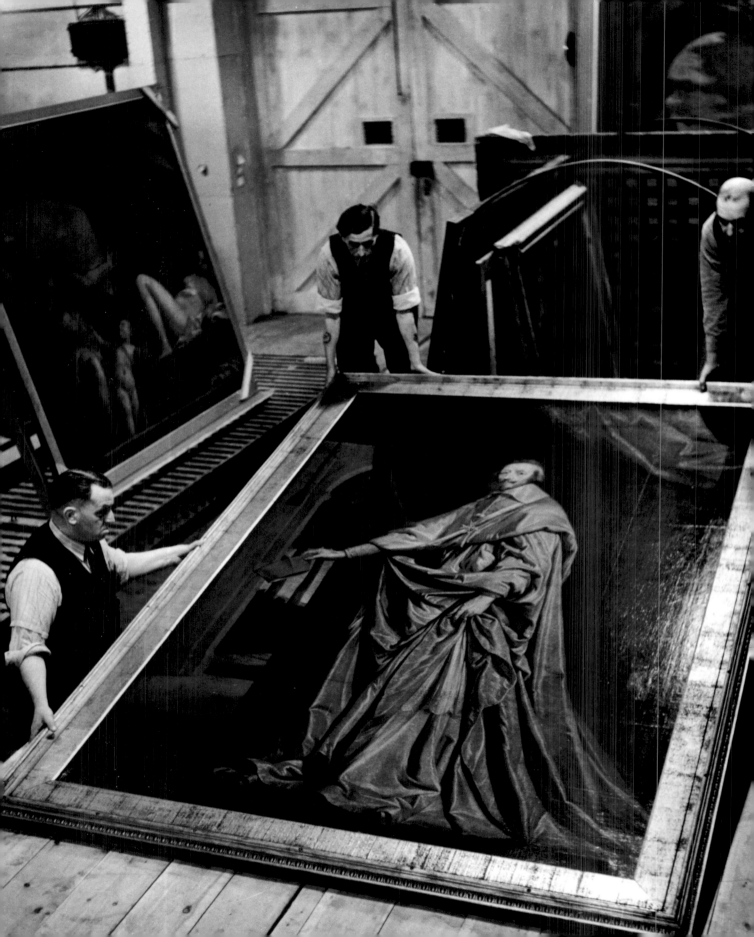

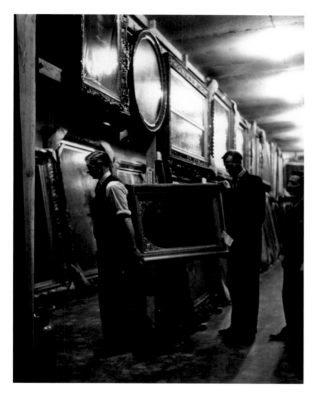

regularly. Hygrometers measured the relative humidity in each building – there were no blankets soaked in streams to regulate the humidity here! The lighting and temperature were constant, with an emergency generator in place should the normal electricity supply fail. An unforeseen consequence of the collection's evacuation to Wales was the opportunity to observe the effects of constant conditions in a way that had never been possible in Trafalgar Square. It was here at Manod that the importance for paintings of constant temperature and humidity was confirmed. This had always been assumed, but until now it had never been possible to prove.

Another unforeseen consequence was that Martin Davies was able to bring the National Gallery catalogues up to date during his 'exile' in Wales. He did not have access to works in museums in Britain and abroad for comparison, but he could study the whole collection in relatively favourable conditions, aided by the fact that the National Gallery's library had been moved to Wales with the paintings.

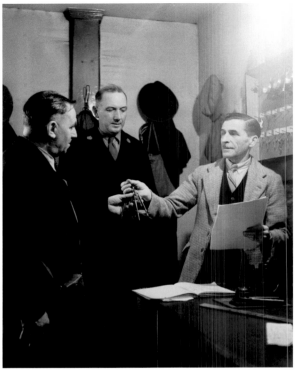

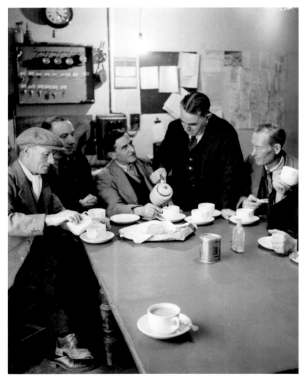

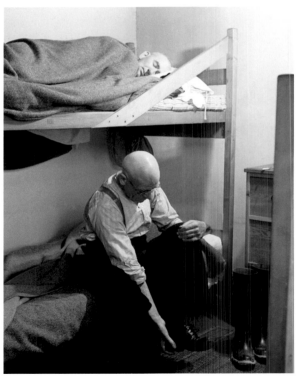

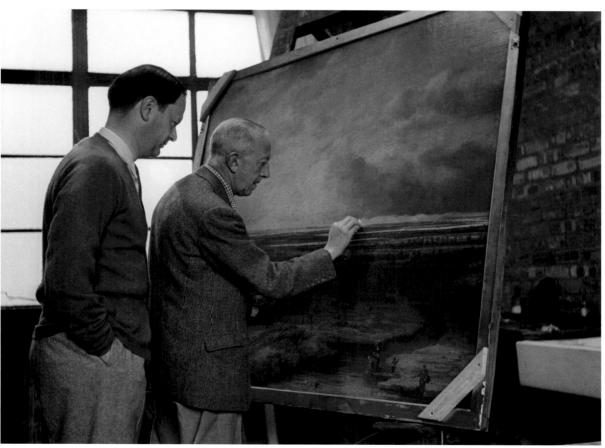

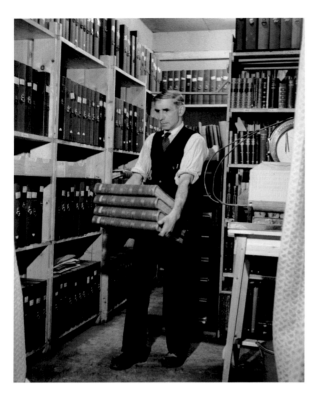

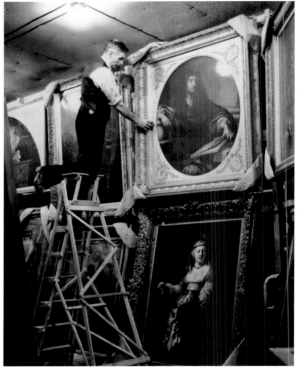

ABOVE LEFT The library was evacuated from London, enabling Martin Davies to pursue his research for the new catalogues of the collection. Back in London the Gallery library had been badly damaged by the explosion of a time bomb on 22 October 1940.

ABOVE RIGHT The brick huts were crowded – in addition to around 1,800 of the Gallery's paintings at Manod were a number of works from other Collections, so the paintings were hung in double rows to save space. Here *Portrait of a Man*, attributed to Gabriel Revel, hangs above Rembrandt's *Saskia van Uylenburgh in Arcadian Costume*.

RIGHT A member of staff makes a telephone call in front of Parmigianino's *Madonna and Child with Saints John the Baptist and Jerome*.

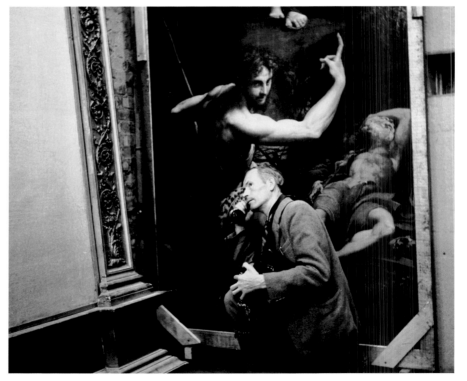

New editions of *The Early Netherlandish School*, *The British School*, *The French School* and *The Earlier Italian Schools* were all completed at this time. In his memoirs many years later, Kenneth Clark said that Davies 'had always been a solitary character, and was said by his contemporaries at Cambridge to have emerged from his rooms only after dark; so this sunless exile was not as painful to him as it would have been to a less unusual man. In the morning he would emerge, thin and colourless as a ghost, and would be driven up to the caves, carrying with him a strong torch and several magnifying glasses. With these he would examine every square millimetre of a few pictures.' A studio was built at the entrance of the quarry where the Gallery's restorers, A.W. Holder and Helmut Ruhemann, were able to work in daylight on the paintings, and a general cleaning programme was carried out.

However, the installation at Manod was not without its hazards. Although the caves were far more stable than other quarries considered for the task, there was nevertheless the danger of rock falls. The brick chambers protected the pictures from minor falls, but there was always the possibility of the whole collection being buried in a catastrophic collapse. As Martin Davies observed in a pamphlet published in 1946, *The War-Time Storage in Wales of Pictures from the National Gallery, London*, 'It would have been useless to save the pictures from bombs, only to crush them in Wales with tons of slate falling on them. Manod Quarry roofs are safer than most; nevertheless, the pictures could not walk away like a gang of quarrymen from any doubtful section.' On 21 November 1942 there was a minor rock fall. No damage was done, and scaffolding was erected to stabilise the ceiling.

But on 9 March 1943, a more substantial fall occurred. Davies cabled to London: 'Another fall of rock behind building no. 2 stop this time boulders penetrated back wall stop one Poussin torn but repairable stop one Ruisdael slightly damaged stop trivial scratches on three others stop building now being cleared of its contents stop Vaughan [the manager of the quarry] is here stop will communicate with the Ministry of Works stop . . .'.

VIEW FROM THE QUARRY HUT

SMALL POND NEAR THE HUT

SNOWDON RANGE

STUDIO AND HUT

THE HUT FROM THE WINDGAGE

SNOW DECEMBER 42

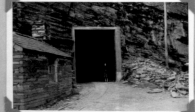

1941 ENTRANCE TO THE QUARRY BEFORE ALTERATIONS

1941

POND OUTSIDE QUARRY ENTRANCE 194

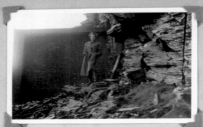

TO THE PICTURES.

THE CATERPILLAR.

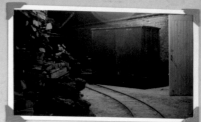

THE TRUCK GOING INTO NO3.

THE TRUCK OPEN.

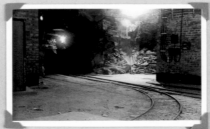

ENGINE ROOMS AND RAIL POINTS

NO 2 ENGINE ROOM.

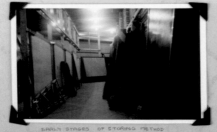

EARLY STAGES OF STORING METHOD

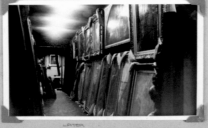

LATER

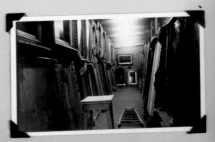

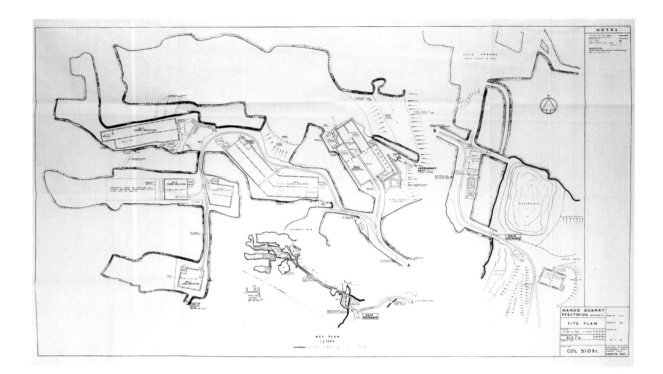

PREVIOUS A double page from a National Gallery album of wartime photographs showing the exterior and interior of the mines, with views of the surrounding area.

ABOVE A Ministry of Works plan of Manod quarry showing the disposition of the specially built brick huts inside the caves numbered 1 to 5.

RIGHT Potentially disastrous rock falls occurred several times during the collection's stay. Scaffolding was built to consolidate the roofs and enable engineers to monitor the state of the caves.

OPPOSITE (detail) A close-up of the plan above, showing the different store buildings in a network of tunnels linked by railway tracks. The central block shows the base of the building that was destroyed by rock falls in 1942–43.

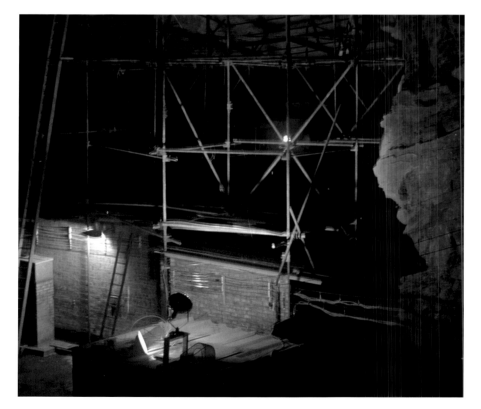

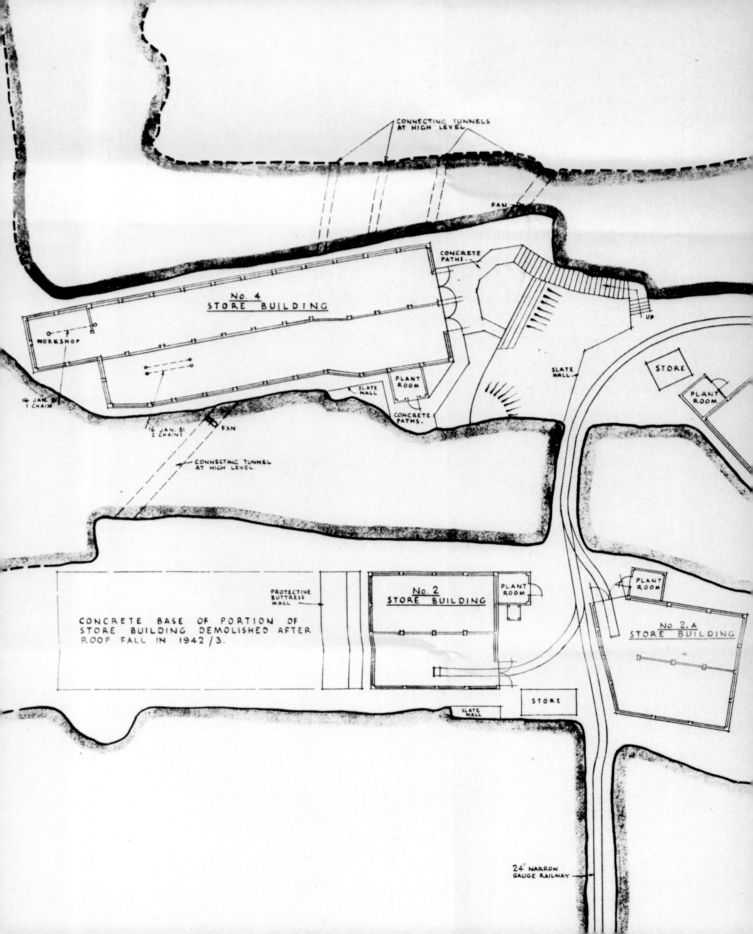

The paintings Davies referred to were Poussin's *Cephalus and Aurora* (NG 65) and Jacob van Ruisdael's *A Road Leading into a Wood* (NG 2563).

Three hundred pictures were moved out of the building affected by the rock fall in seven hours, and plans to evacuate the whole quarry were seriously considered, but set aside after generally favourable reports from civil engineers on the condition of the quarry as a whole. It is likely that the heating of the buildings erected within the caves had affected the rocks above and made them more friable. Regular inspections were carried out by the Ministry of Works and Mining Inspectorate, and there were no further significant rock falls for the rest of the time the paintings were in residence.

Although the exact location of the National Gallery repository in Wales was not generally known for security reasons, there were articles about it in various papers and magazines, and it was not long before requests came in from other museums and collectors for safe storage. In addition to the National Gallery paintings, the quarry came to house works from the Courtauld Institute, National Portrait Gallery, Soane Museum and Victoria and Albert Museum in London, the Walker Art Gallery in Liverpool and the Fitzwilliam Museum in Cambridge, to mention but a few. The Royal Collection had arranged for drawings by Leonardo, Holbein, Claude and Michelangelo to be sent to Manod; the librarian at Windsor then wrote: 'When I was speaking to the King and Queen two days ago about sending the drawings to Ffestiniog, Their Majesties warmly commended the scheme and went on to ask whether some of the more valuable paintings might not go too'; and paintings joined the drawings.

As the war progressed on other fronts, the threat from bombs lessened and selected paintings were taken up to London periodically to feature in small exhibitions. Kenneth Clark later observed that he always felt guilty taking pictures back to London since they seemed so happy in Wales. In all, the storage at Manod and in Wales as a whole was a success, despite the occasional moments of high anxiety. When the war came to an end, one private owner, whose paintings had been stored at Bangor, wrote to thank Davies. 'They look as if they thoroughly enjoyed their five years in Wales. In fact they don't look a day older...'

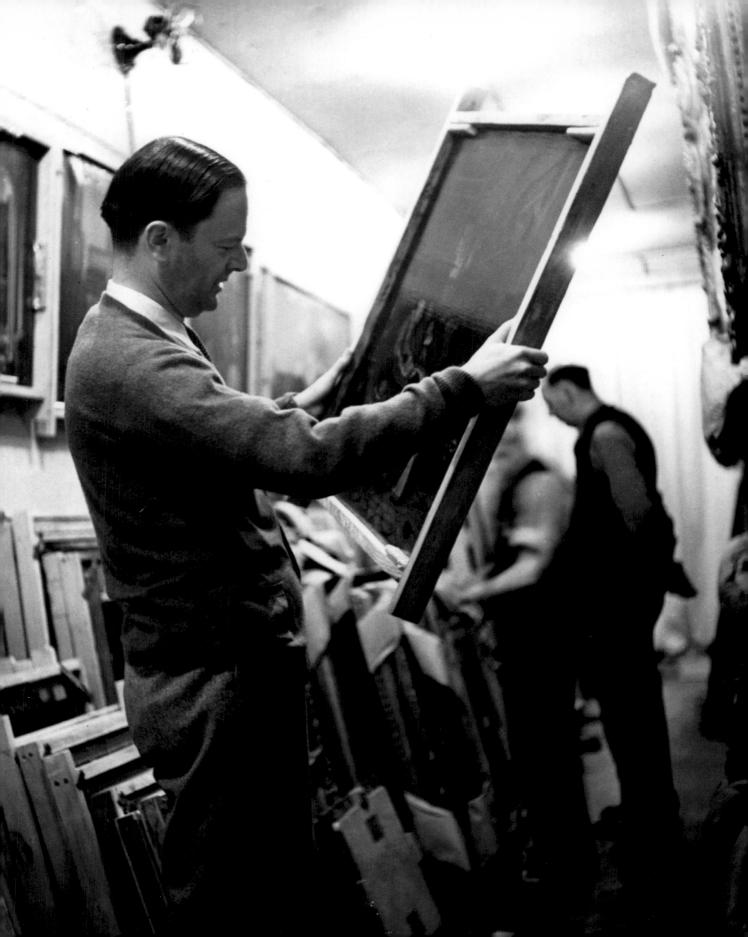

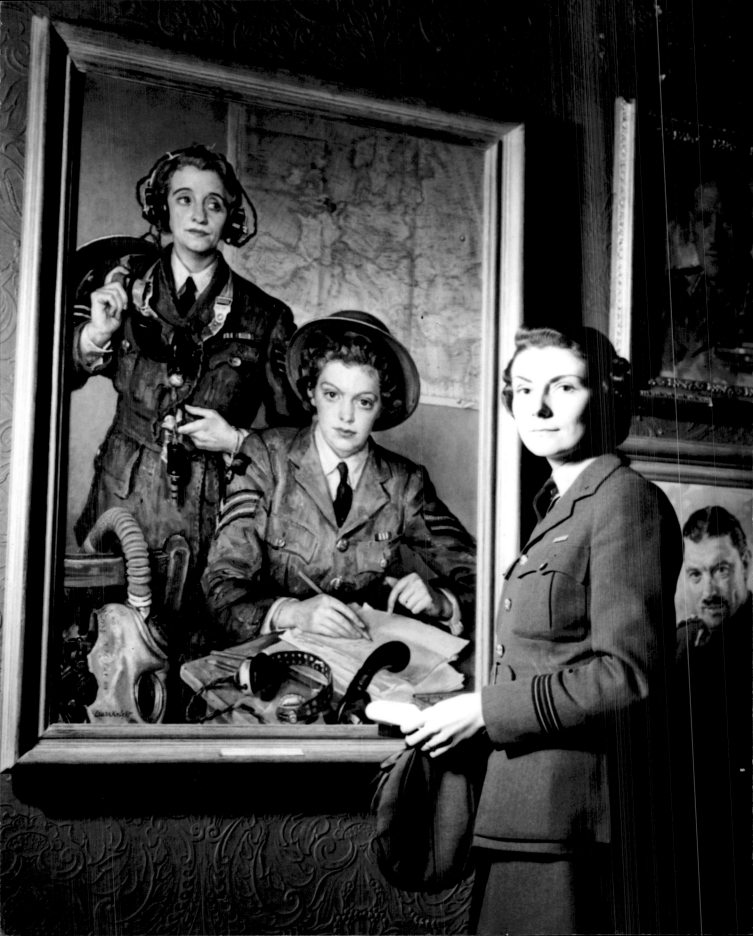

Exhibitions under fire

Encouraged by the crowds that came flocking into the Gallery to hear the Myra Hess concerts, Kenneth Clark and the trustees realised that there was an appetite for cultural activities that the war had heightened, especially since many other museums and galleries had closed, and it was decided to stage temporary exhibitions.

The first one opened at the end of March 1940. Entitled *British Painting Since Whistler*, it was organised by Lillian Browse (formerly of the Leger Galleries), and consisted of loans from private collections. It was well attended by the public, but generally poorly received by the art establishment and art press. One member of the Royal Academy commented: 'If British painting were only what is showing at Trafalgar Square, heaven help it.' Undaunted, the Gallery continued to consider any options offered.

Earlier, in 1939, Clark had suggested to the Ministry of Information the setting up of a 'War Artists' Advisory Committee', similar to a Canadian scheme organised during the 1914–18 war. Although slightly sceptical of the group's potential artistic worth – 'I was not so naïve as to suppose that we should secure many masterpieces, or even a record of the war that could not be better achieved by photography' – he was keen to keep as many artists as he could at home: 'My aim, which of course I did not disclose, was simply to keep artists at work on any pretext, and, as far as possible, to prevent them from being killed.' The first official WAAC exhibition opened at the Gallery in July 1940, and a continually changing display of pictures throughout the war attracted a wide spectrum of visitors. Among the many artists shown were Edward Bawden, Edward Ardizzone, Eric Ravilious, Stanley Spencer, Henry Moore and Barnett Freedman (the latter also designed the cover of the

OPPOSITE In its coverage of one of the WAAC exhibitions the *Tatler and Bystander* described this photo in detail: 'Dame Laura Knight has painted two W.A.A.F. heroines, Assistant Section Leader E. Henderson and Sergeant H. Turner, who were two of the first three members of that service to be awarded the Military Medal – for courage and devotion to duty during raids. Beside the picture stands Flight Officer Mrs Hanbury, MBE, W.A.A.F.'

Sir Muirhead Bone (right) in July 1940 selecting works for the War Artists exhibition at the Gallery.

BELOW Servicemen discussing Charles Cundall's 1940 painting, *The Withdrawal from Dunkirk, June 1940*. The painting is now in the Imperial War Museum.

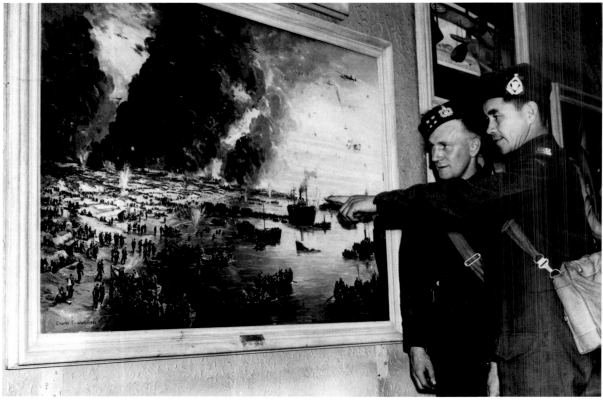

concert programmes). Accompanying these younger artists were an older generation, who had already documented the earlier war, such as Paul Nash, Sir Muirhead Bone and Eric Kennington. Despite Clark's wish to keep them out of harm's way, many of the younger artists did serve in the armed forces in many of the main theatres of action, and a number lost their lives, most notably Eric Ravilious, who was killed during an operational flight over Iceland in September 1942.

There were also traditional shows of the sort one would associate with the Gallery, such as *Nineteenth Century French Paintings* in 1942, and more adventurous exhibitions of the works of Augustus John and Jack Butler Yeats. The Gallery also housed several shows organised by the Tate Gallery, whose Millbank buildings had been severely damaged by bombing. Many

outside organisations were invited to show at the Gallery, too, resulting in a huge variety of 'non-art' exhibitions: these included *Recording Britain, Ballet Design*, and *Greater London, Towards a Master Plan. Design at Home*, held in 1945, showed ideal interiors for post-war homes. Given the number of residential buildings destroyed in London and elsewhere by the bombings, large-scale and speedy reconstruction was going to be needed, and this show demonstrated what would be on offer. Lord Woolton, formerly the popular Minister for Food and now Minister for Reconstruction, stated at the opening: 'Houses will be built in large quantities in the next few years. Some will be condemned by artistic people. But it is better to have prefabricated houses than no houses, and better to have prefabricated houses than prefabricated ideas.'

RIGHT A shot of the interior of the William Nicholson and Jack Butler Yeats exhibition held in 1942.

BELOW RIGHT A photograph of the model sitting room in the 1945 exhibition, 'Design Your Home', organised by CEMA (the Council for Education in Music and the Arts). The exhibition displayed a sequence of life-size rooms (dining room, children's room, bedroom, kitchen, etc.), demonstrating how the homes of the future might look.

BELOW LEFT Before the war, temporary exhibitions in galleries were a rarity. Lillian Browse had worked at the Leger Galleries before the war, meeting Kenneth Clark on several occasions. Enlisted into the ambulance service at the beginning of the war, she attended several Myra Hess concerts during her time off and constantly badgered Clark to stage a loan exhibition in the Gallery to cover the then-empty walls. She eventually succeeded and organised the first wartime temporary exhibition, *British Painting since Whistler*.

OVERLEAF Visitors view a War Artists exhibition at the National Gallery.

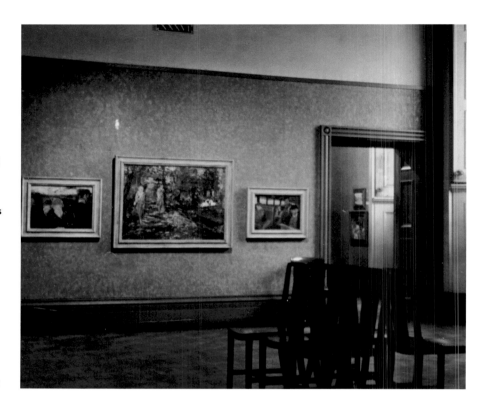

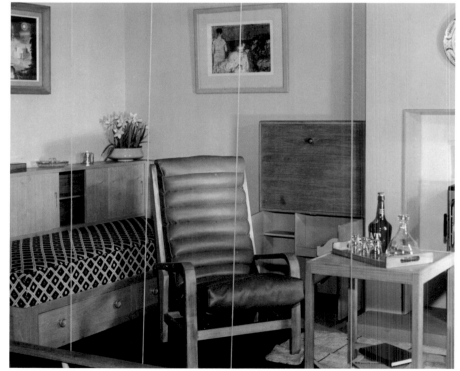

Visitor numbers at all these shows was high. The *Nineteenth-Century French Paintings* exhibition attracted 37,000 people in 38 days. The day after the opening, Kenneth Clark received an indignant letter from General de Gaulle (then the leader of the Free French in exile in London and later to be the President of France) demanding to know why he hadn't been invited to open the exhibition. Clark said, 'I replied that it was part of the routine work of the Gallery and that in any case I disliked opening

ceremonies on principle.' Despite – or maybe because of – his frank reply, Clark was invited to lunch by the General, and they were to meet again amicably several times during the war.

In 1942 the 'Picture of the Month' scheme began, which was to become immensely popular. Following the acquisition of Rembrandt's *Margaretha de Geer* (NG 5282) and its display for three weeks in splendid isolation in one room of the Gallery, a correspondent to *The Times* asked whether the scheme could

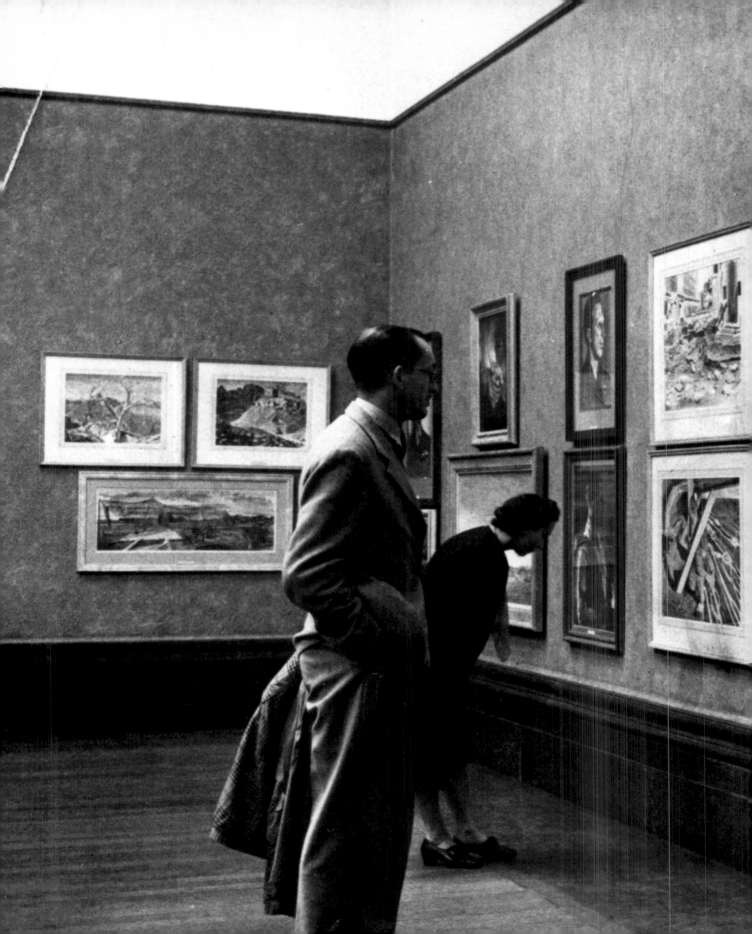

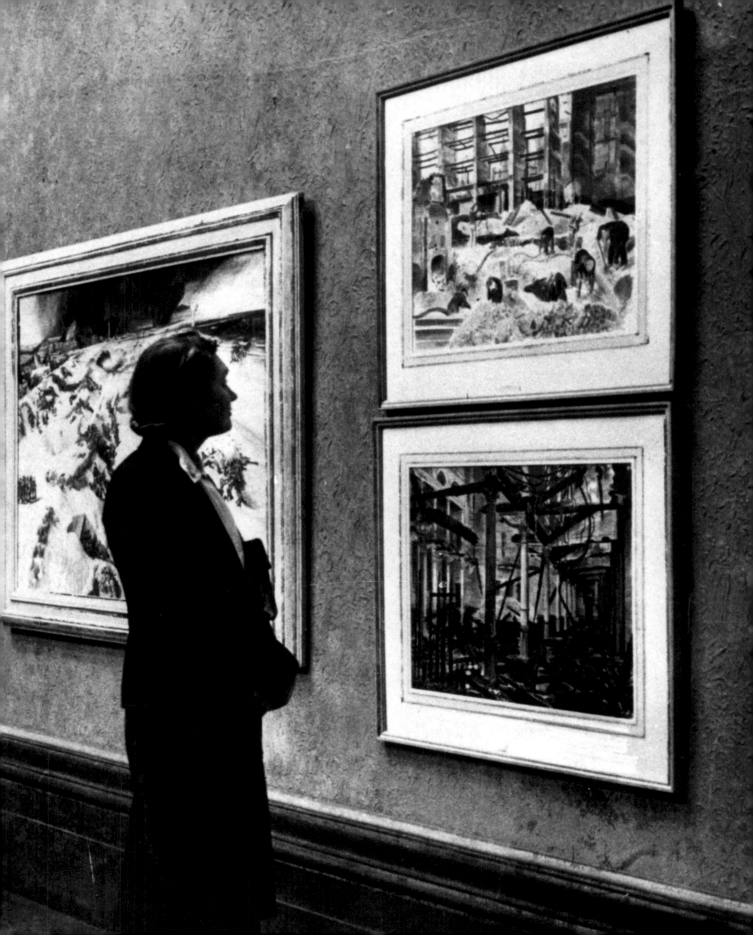

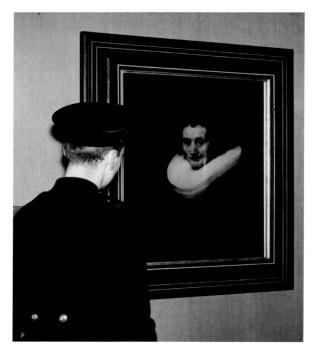

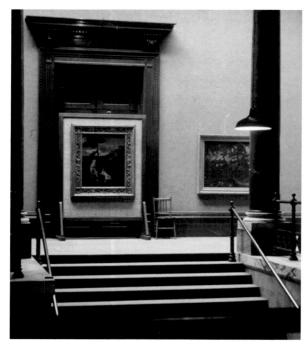

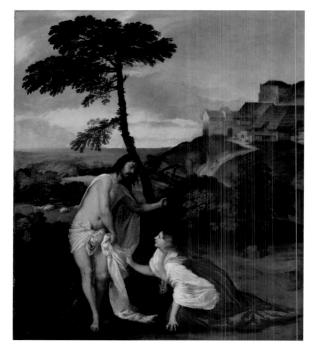

OPPOSITE ABOVE LEFT
A serviceman examines Rembrandt's *Margaretha de Geer*. Newly acquired in 1941, its exceptional display in the Gallery early in 1942 inspired the hugely popular 'Picture of the Month' scheme.

OPPOSITE BELOW LEFT AND LEFT Views of the installation of Titian's *Noli me Tangere*, the first 'Picture of the Month'.

not be repeated on a regular basis with works from the permanent collection. The bombing raids had lessened considerably, and it was decided to risk bringing one painting up from the quarry in Wales each month and putting it on show. Every night it would be removed from the wall and taken down to the shelter for safety. The first work to follow the Rembrandt was Titian's *'Noli Me Tangere'* (NG 270). It was accompanied by display panels showing comparative material and X-ray photographs – a technique in which the scientific advisor, Ian Rawlins, was a pioneer. In total, 43 paintings were shown individually in this way, including Velázquez's *Toilet of Venus ('The Rokeby Venus')* (NG 2057), Bellini's *Agony in the Garden* (NG 726), and El Greco's *Christ driving the Traders from the Temple* (NG 1457). The arrival of each picture in London was a news event, attracting large numbers to the display.

Just as the concerts continued uninterrupted during the worst days of the Blitz, the various exhibitions continued throughout the war. In 1941 Herbert Read wrote that the Gallery was 'a defiant outpost of culture right in the middle of a bombed and shattered metropolis.' Occasionally, particular rooms had to be shut for repairs to shattered glass in the roof, and there was much discussion as to whether people should be obliged to leave the building during air-raid alerts, which were frequent – sometimes occurring several times a day. During the years 1940–5, an extraordinarily varied group of exhibits were shown in Trafalgar Square, to a more diverse audience than ever before. But, as the success of the 'Picture of the Month' scheme showed, Londoners missed the permanent collection and, with the cessation of hostilities in Europe, it was time for the Gallery's own paintings to return.

For a full list of wartime exhibitions, see page 126.

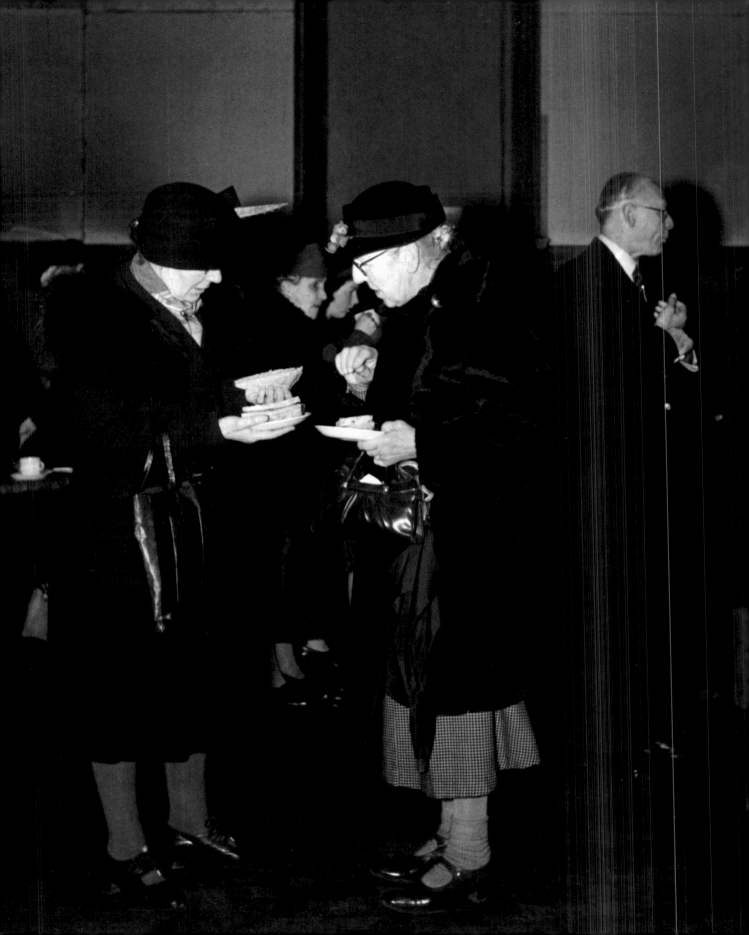

Sandwiches and sonatas

While the musical content of the Myra Hess concerts was uncompromising, their atmosphere was informal, and members of the audience were encouraged to come supplied with sandwiches. But as their huge success became obvious, it soon became apparent that there was a need to provide some sort of refreshment.

In his BBC broadcast only a few weeks after the start of the concerts, Kenneth Clark said: 'People who have missed their lunch want something sustaining in the way of music. Not that they need all miss their lunches, because they are encouraged to bring sandwiches, if they can manage not to crackle the paper, and next week we hope to have a sandwich counter of our own.'

A group of twenty-five formidable ladies, led by Lady Gater, volunteered to undertake the catering for the lunchtime concerts, and within weeks their sandwiches came to be known as the best in London. Lady Gater's husband happened to be Sir George Gater, Permanent Secretary to the Ministry of Supply – a useful connection when provisions for the canteen needed to be found. Myra Hess referred to Lady Gater and her volunteers as 'the good fairies of our digestion'. All the profits went to war charities (the RAF Benevolent Fund, the National Gallery Concerts Fund, the King George Fund for Sailors, among others), and large sums were raised.

Joyce Grenfell, later famous for her roles in the hugely popular series of *St Trinian's* films, volunteered to help, and had fond memories of her time at the Gallery: 'I am one of thousands who were nourished by these concerts. I went to work in the canteen that provided sandwiches and excellent coffee before the music began at 1.10pm. We made delicious sandwiches, new to me, with fillings of honey and raisins in brown

OPPOSITE Two redoubtable ladies from a lunchtime concert audience give the sandwiches on offer a critical inspection.

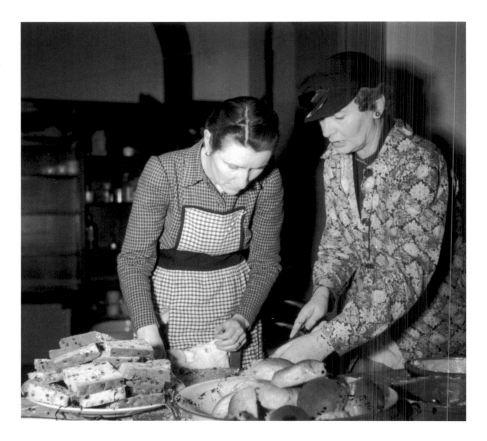

bread, chutney and cream cheese, dates with cream cheese, chopped celery, fish and cress; and now and then home-made pâtés. We buttered and filled from 10.30am (one day we made seventeen hundred sandwiches and would have made more but the bread ran out).' In Humphrey Jennings's film *Listen to Britain*, a group of women happily settle down to eat their sandwiches on the steps leading up from the main entrance.

The concert sandwiches were so popular that it became obvious there was a clear demand for good-quality catering, and the possibility of opening a second canteen – this time reserved for war workers – was suggested. Known as the Whitehall Canteen, it was situated in the East Wing of the Gallery in an area occupied today by the National Gallery Café. As with the sandwich counter, it became an overnight success, and was packed day after day. *The Times* described its beginnings: 'Lady Gater and one or two friends one day provided sandwiches and cartons of milk. Soon a power point was installed and hot coffee became possible. Next pots and pans were borrowed from friends, more power points were fixed, and the first hot luncheon was cooked. One of the volunteer cooks ran out into Trafalgar Square and invited a dozen Australian soldiers to come in and try it. Since that day the canteen has never lacked customers. If it were twice as large it would still be too small. Today

RIGHT The canteen committee standing in Trafalgar Square during 'Wings for Victory' week in March 1943. Note the Lancaster bomber in the background, parked next to Nelson's Column.

BELOW Lady Gater (far left), in conversation with another member of the canteen committee.

OPPOSITE LEFT Joyce Grenfell with Myra Hess (centre) and Howard Ferguson. Joyce Grenfell became a good friend of Myra Hess and frequently attended her concerts. She wrote, 'Last Tuesday I worked at the Gallery all the morning and it was a huge day. We had 1200 people in to hear Myra and Isolde Menges play Beethoven sonatas. After the concert Myra and several others and myself all sat on in the artists' room talking for ages. It is so cosy the way we use the National Gallery as a home.'

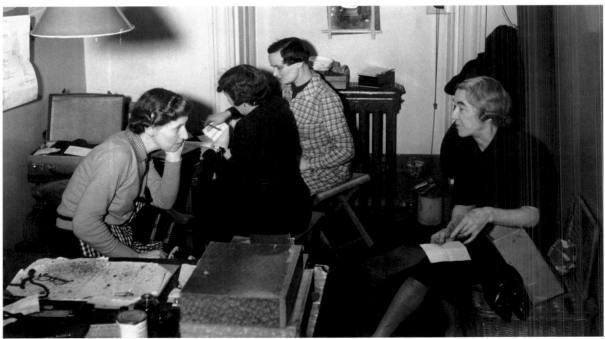

the daily average of meals served is 1,460, and sometimes the figure is as high as 2,200… Because it is so popular and although the trustees have from time to time added to the accommodation they have provided, eating is a somewhat crowded, but thoroughly friendly affair. In summer, the diners overflow on to the lawn outside the Gallery. The cramped conditions inside are, however, more than outweighed by the excellence of the fare provided. This is due to the inventiveness of the volunteer cooks under the head cook, Mrs Geoffrey Kirk, an amateur who, formerly an executive with a leading dressmaking house, is making the utmost use of her experience as a consumer of the cooking in France and Italy before the war.'

The press covered the work of the volunteers enthusiastically, with feature articles published in magazines such as the *Bystander*. In the *Star*, a journalist recounted how 'Lady Gater showed me her dog-chewed copy of "Something New in Sandwiches" by Redington White, as the source of her novelties, but I gather that a good many of the sandwiches are original creations of her team of voluntary workers. For those who wish to experiment, I can commend sandwiches made with honey and walnut, curried egg, and lobster and cream. The popular one is honey and raisins.'

LEFT 'I'm sure it was in here somewhere.' Two volunteers try out the newly installed potato peeler, purchased out of the canteen's running expenses.

BELOW A hive of activity in the cramped conditions of the canteen kitchen. The canteen was rather unkindly blamed for some unwelcome visitors to the Gallery. One of the curators recalled how he came face to face with a large rat while he was patrolling through the Gallery near the kitchen one night. The guard accompanying him instructed him to keep the rat fixed in the beam of his torch while he went away to get an iron bar. When the guard returned, he dispatched the rat with one blow.

RIGHT AND BELOW Unlike
the concert sandwich counter,
which was open to the public,
the Whitehall Canteen was
only open to war workers,
including civil servants and
members of the armed forces.
Every day huge numbers
crammed into the small
canteen area.

OPPOSITE Customers queue
up outside the Whitehall
Canteen entrance, to the
east of the portico. Flags
of the Allied countries hang
from the building. Here,
the flag of the Soviet Union
and France can be seen,
with a tiny portion of the
US flag visible through
the columns of the portico.

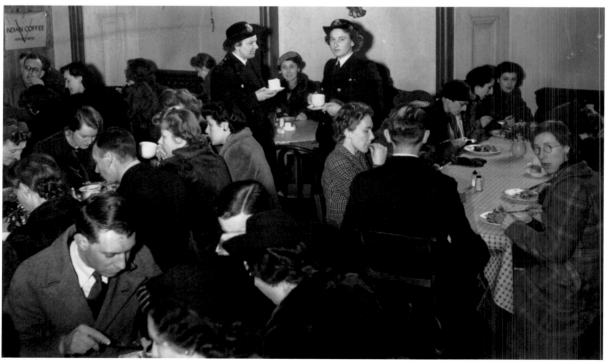

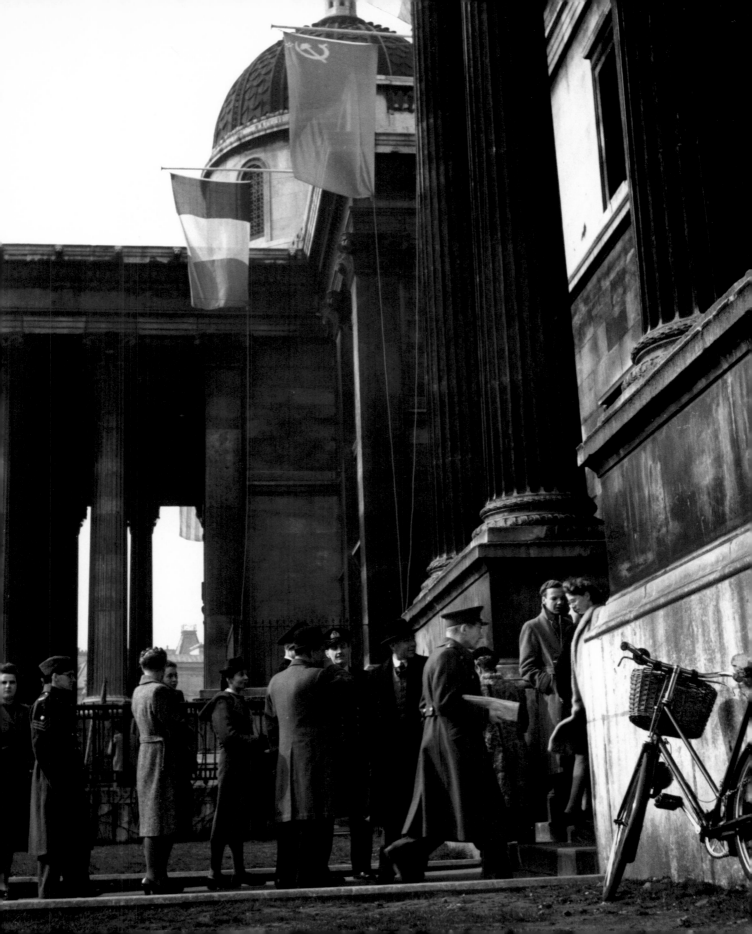

RIGHT Mrs Gordon Halland and Lady Savil serve coffee at the table in the main canteen, under the watchful gaze of Duncan Grant's paintings, originally painted for the Cunard Line.

OPPOSITE Mrs 'Poppy' Kirk, head cook, in the kitchen of the canteen.

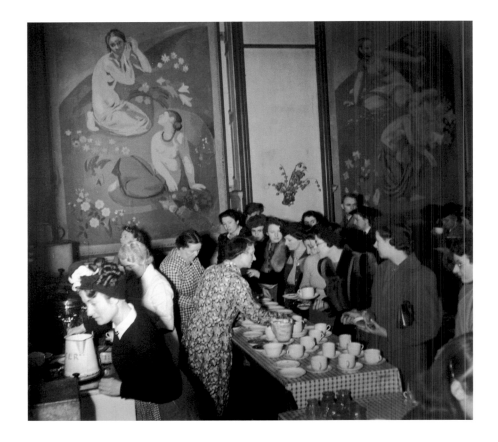

One wall of the canteen was decorated with large panels by Duncan Grant that were originally intended for the main lounge of the *Queen Mary*. Completed in 1935, they were considered unsuitable for the liner by the Cunard board, and rejected. When the canteen opened, Kenneth Clark asked Grant whether he might borrow them for the Gallery, and they adorned the walls throughout the war.

At the time, the provision of catering in a gallery was unusual and the innovation was not universally welcomed. A dyspeptic letter appeared in the *Daily Telegraph* at the end of the war: 'Finally let us hope that, with the return of the pictures, there will also be a return to standards befitting one of the greatest galleries in the world, that the visitor will no longer be faced with picnic parties on the steps and verges, hindered by milk churns in the entrance, and assailed by the stench of food in the halls.'

Yet the crowded canteen proved this was a minority view, and the Gallery authorities themselves felt that the canteen should have a future in peacetime. In notes concerning the reconstruction and post-war plans for the Gallery, it was stated that 'the experience of the last few years suggests that even in peacetime, a refreshment room would be appreciated. Both students working in the Gallery all day and people who could only spare an hour at lunchtime would welcome it.' The 'good fairies of our digestion' had won the day.

Homecoming

With Germany's unconditional surrender confirmed on 7 May 1945, revellers began to mass in London streets and squares on the following day, declared 'Victory in Europe Day'. For the first time in years, the National Gallery closed its doors, and remained shut on 9 May, also declared a national holiday. Trafalgar Square was full of celebrating crowds, although those who had also seen the celebrations at the end of the First World War commented that they seemed more muted this time, as if people were relieved rather than exuberant that the war was at last over.

Within days, a selection of masterpieces returned from Wales for a reopening of the permanent collection in two rooms on the less damaged eastern side of the Gallery. A *Manchester Guardian* article commented: 'No fanfare of trumpets heralded the return of sixty of its most famous pictures to the National Gallery a few days ago, yet their presence in the first two rooms on the right of the entrance hall is surely the completest symbol of victory in Europe.' Among the works returned were Bellini's *Doge Leonardo Loredan* (NG 189), van Eyck's *'The Arnolfini Portrait'* (NG 186), Hobbema's *The Avenue at Middelharnis* (NG 830) and Titian's *'Noli Me Tangere'* (NG 270). The exhibition was opened by King George and Queen Elizabeth on 17 May. A journalist remarked how bright the works seemed after their years of absence, all the more appreciated in a city full of bomb damage. 'The Gallery was full: one had almost to queue up for a glimpse of van Eyck, who seemed to outdistance even Rembrandt and Velázquez in popularity: Flemish and Dutch were the general favourites. In these years of dust and rubble and drabness any clean, bright colour has a tremendous appeal, and how rich are the red and apple-green in van Eyck's portrait of the Arnolfinis, like an

OPPOSITE Rapturous celebrations take place in Trafalgar Square on 'Victory in Europe Day'. The columns of the National Gallery are visible in the background.

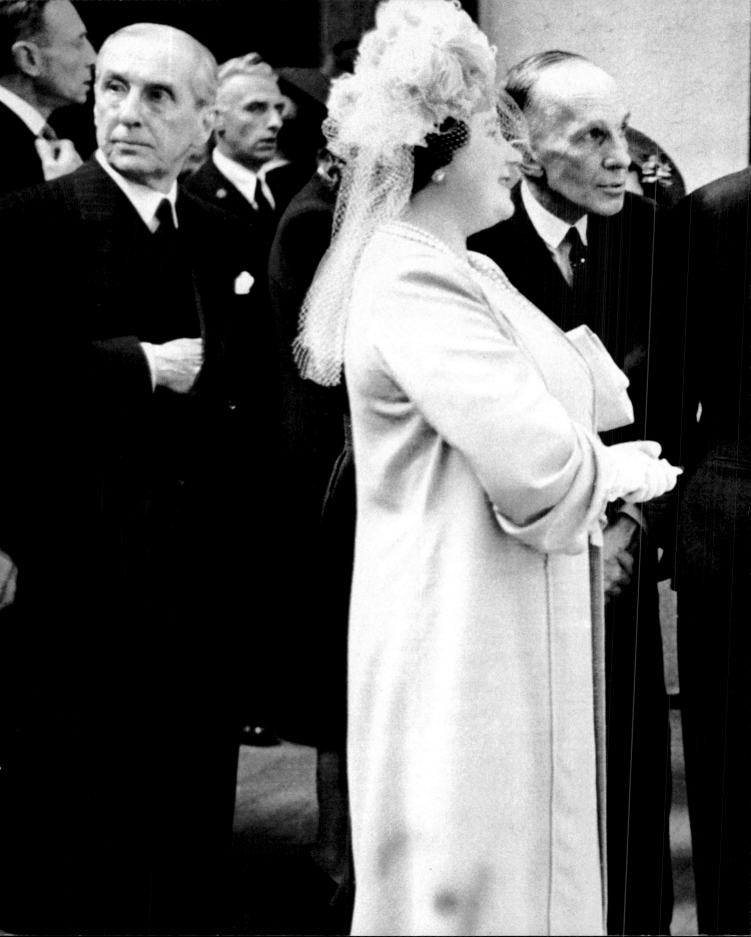

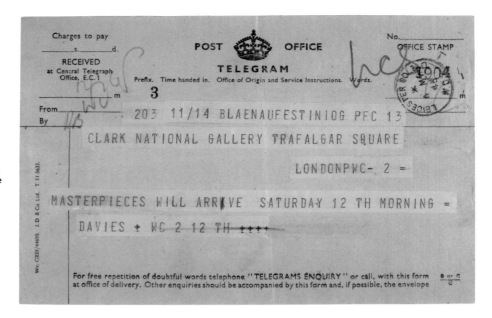

PREVIOUS The King and Queen visit the newly reopened Gallery in May 1945. King George VI (centre) views the exhibition with Queen Elizabeth. Kenneth Clark, soon to resign as Director, stands next to the King.

RIGHT A telegram from Martin Davies in Wales to Kenneth Clark announcing the imminent return of the paintings destined for the reopening of the Gallery.

orchard's russet kingdom for these two sombre souls. No generalisation would cover the Saturday crowd: it seemed to be of all ages and occupations and purses.'

In June, the great Van Dyck equestrian portrait of Charles I in its 'Elephant Case' was manoeuvred back into the Gallery through the entrance with a few inches to spare. Within six months, all the paintings had returned – but their accommodation proved problematic. The Gallery was in a sorry state: many of the rooms had lost all the glass in their roofs, and a large number were covered over with corrugated iron. Lack of space meant that the paintings were hung from floor to ceiling in a style more reminiscent of the nineteenth century. The western side of the Gallery was unusable, and no labour was available to make repairs; in any case, the damage was so severe that a thorough restoration of this area was essential, and it was planned to include the

installation of air conditioning for the better conservation of the paintings. The observations in Manod quarry that had proved the importance of constant temperature and humidity could not be ignored, and the scientific department, initially set up in 1935, was considerably enlarged to continue the technical work that had begun so successfully in Wales. In 1946, a conservation department was established within the Gallery to complement the work of the scientific department (before the war, such work had been carried out by outside restorers).

The Gallery had survived the war despite heavy damage, and had – through the most difficult of times – continued to accommodate a remarkable range of activities within its walls. But the coming of peace would bring new challenges. Kenneth Clark decided, once the paintings had returned, that he would step down, so that a new director should oversee the post-war plans for the Gallery.

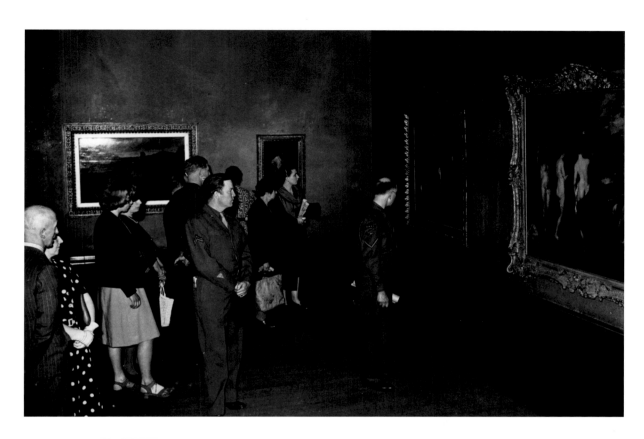

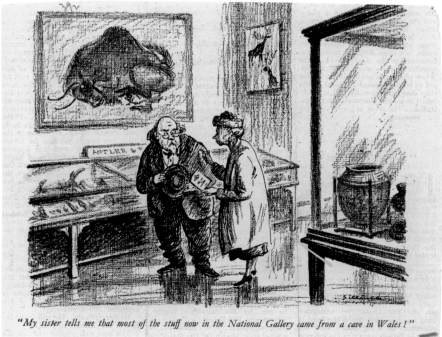

"My sister tells me that most of the stuff now in the National Gallery came from a cave in Wales!"

ABOVE The general public view the newly reopened rooms. A great deal of the building was out of commission due to bomb damage, but a number of rooms in the eastern part of the Gallery were usable for the reopening.

LEFT Appearing in *Punch* in August 1945, the caption of this cartoon reads: 'My sister tells me that most of the stuff now in the National Gallery came from a cave in Wales!'

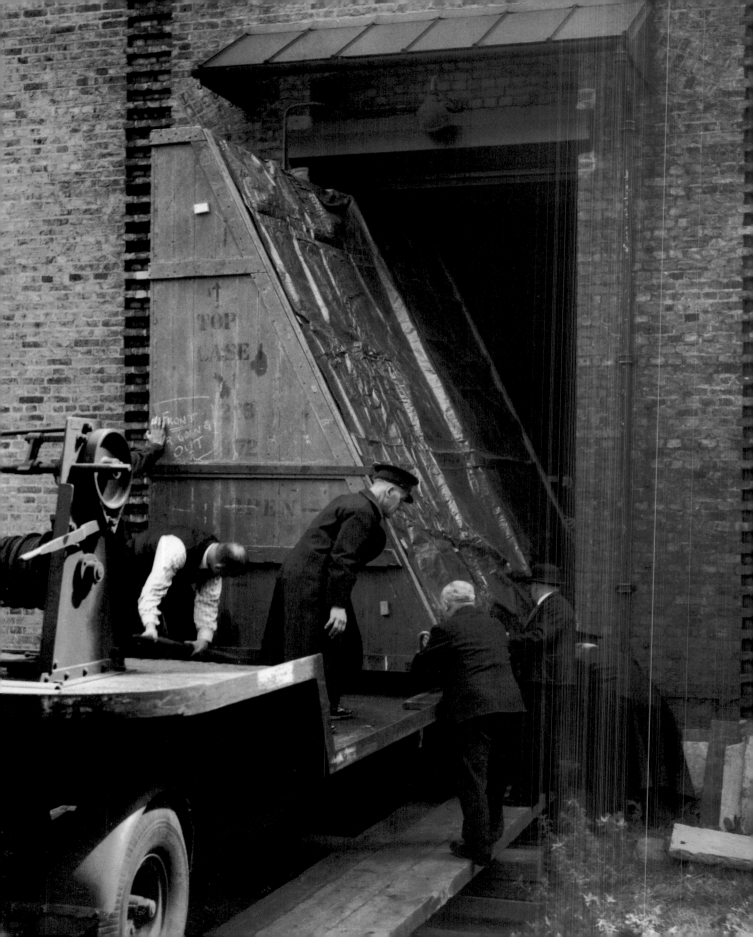

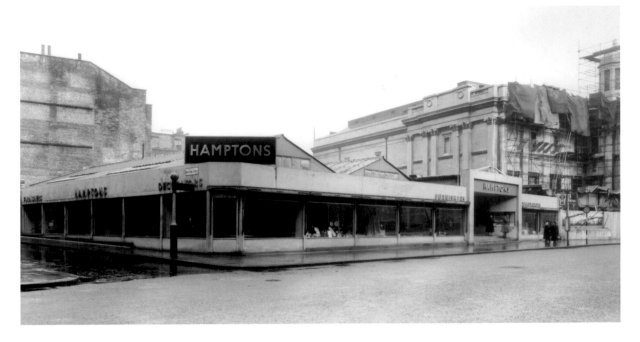

CRAZY CARTOON

" Steady how you go, Bert. I had ' The Fighting Temeraire ' on my toe this morning ! "

OPPOSITE Six years after its departure the 'Elephant Case' is edged, inch by inch, back into the Gallery. As ever, its size and awkward shape required careful manoeuvring.

ABOVE Following its destruction during a bombing raid, the remains of Hampton's Furniture Store was demolished after the war and replaced with a temporary one-storey building. In this 1951 photograph, the West Wing of the Gallery, visible in the background, is covered in scaffolding as repairs to the bomb damage are carried out. The Sainsbury Wing now stands on this site.

LEFT This *Daily Sketch* cartoon's caption reads: '"Steady how you go, Bert. I had 'The Fighting Temeraire' on my toe this morning!"'

OVERLEAF Art handlers moving a painting into one of the galleries in 1947. After the war, a large number of the rooms were out of commission due to damage caused by bombing raids. The restricted space meant that the paintings had to be hung several rows high.

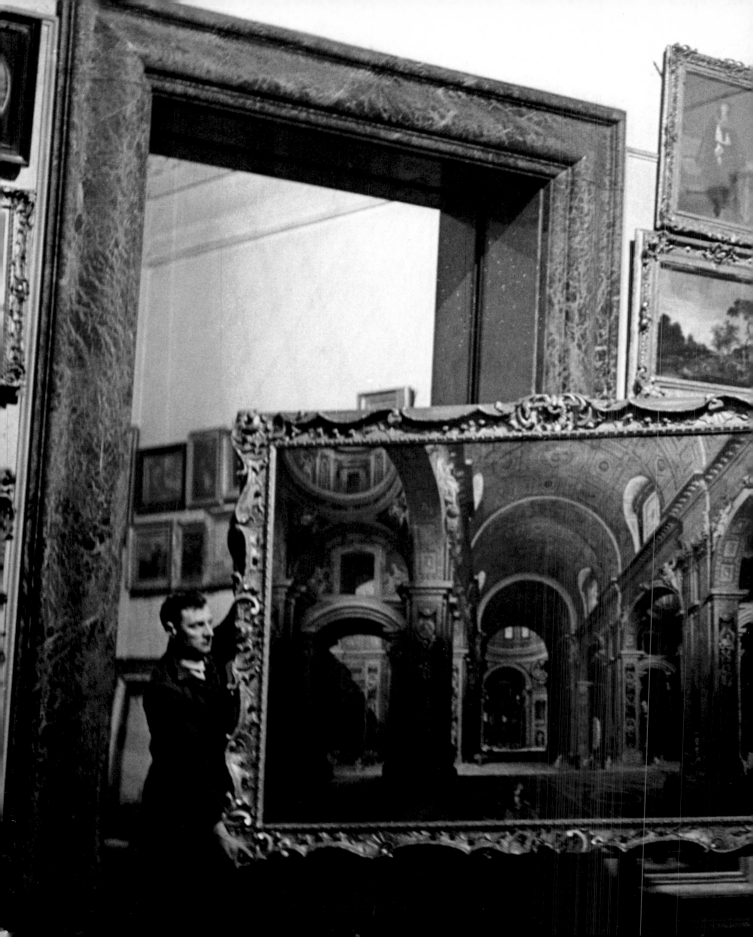

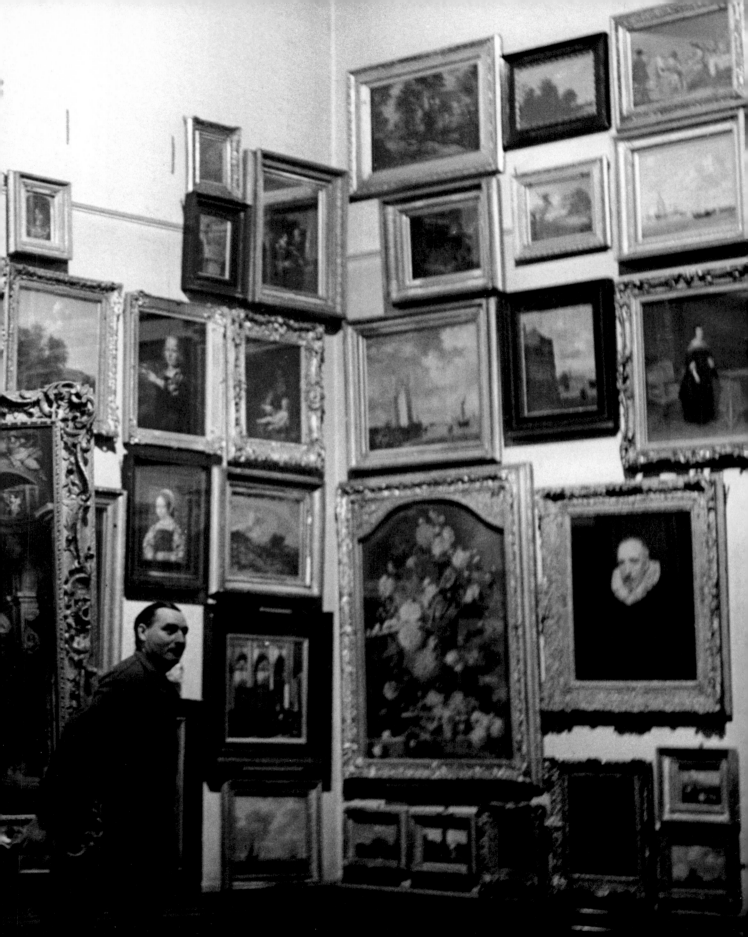

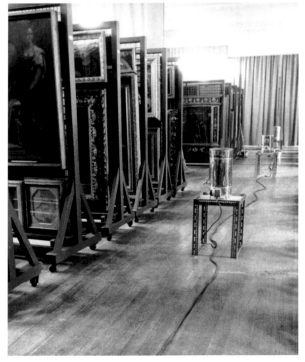

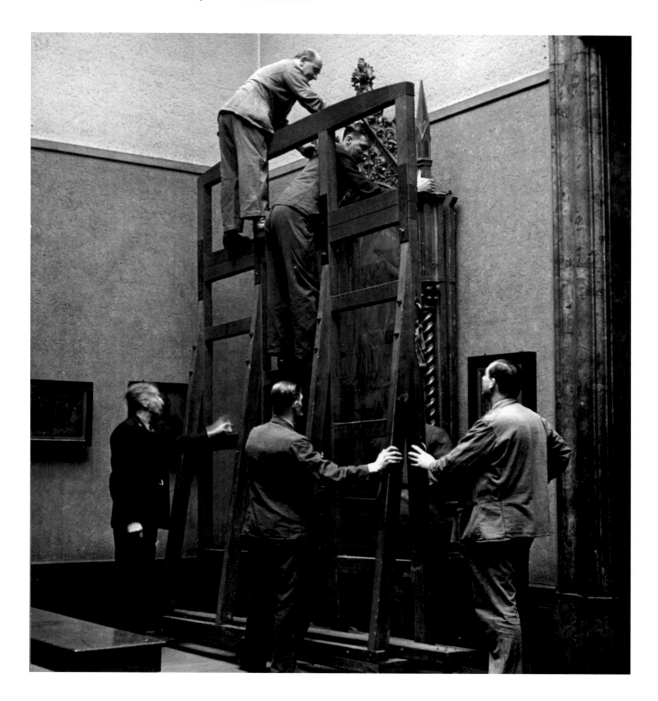

Home at last! In June 1945 the Van Dyck *Equestrian Portrait of Charles I* prepares to return to Trafalgar Square after its numerous adventures. During the war years, it was spirited out of London in a large crate, housed in a neo-Norman fantasy castle, transported in high winds to a remote quarry, stuck under a bridge, stored under 200 feet of rock and finally edged inch by inch back into the Gallery.

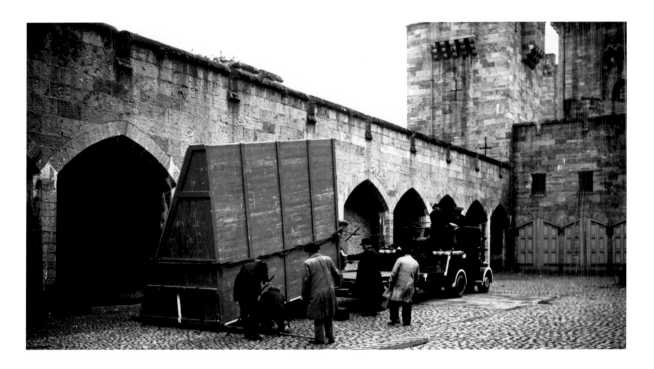

The announcement of Clark's departure was somewhat overshadowed by the appearance on the same day of the general election results, and the news that Britain had elected its first Labour government. Philip Hendy succeeded Clark as Director and oversaw much of the reconstruction in the post-war years. The most important thing was that the paintings were now back where they belonged, many in better condition than when they had left London in 1939. However, it was to take a good decade to repair the Gallery fully and show the collection again to its full advantage.

This book is a tribute to all the people – from Myra Hess and Kenneth Clark, to the warders, fire-watchers, volunteer cooks, artists and musicians – who, in their different ways, made the National Gallery 'a defiant outpost of culture right in the middle of a bombed and shattered metropolis'. It is most of all a tribute to the dedication of those who saved the nation's paintings.

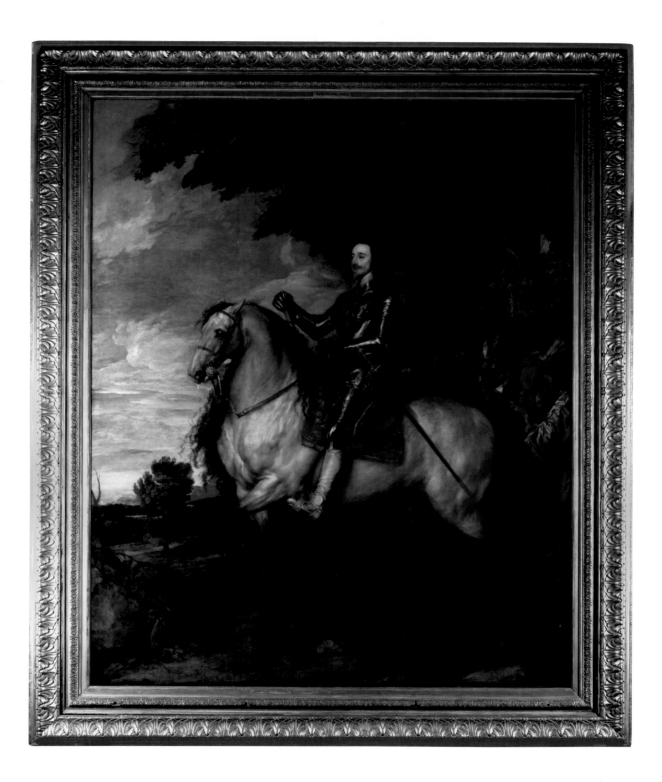

Wartime Exhibitions at the National Gallery

1940

British Painting Since Whistler
Drawings of Augustus John R.A.:
 Some Drawing of the Past Fifty Years
British War Artists

1941

A Whistler and Early Twentieth Century Oils
Six Water Colour Painters of Today
Sickert
Recording Britain
War Artist exhibitions

1942

The Tate Gallery's Wartime Acquisitions
Nicholson and Yeats
Nineteenth Century French Paintings
Pictures Bought by C.E.M.A for Circulation
 in the Provinces
The Englishman Builds
Recording Britain
War Artist exhibitions
Picture of the Month

1943

Memorial Exhibition of the Works
 of Philip Wilson Steer O.M.
Portrait and Character
Ballet Design
English Book Illustration Since 1800
Rebuilding Britain
Greater London: Towards a Master Plan
Recording Britain
War Artist exhibitions
Picture of the Month

1944

National Buildings Record
War Artist exhibitions
Picture of the Month

1945

French Book Illustration 1895–1945
Design at Home
Second Exhibition of the Tate Gallery's
 Wartime Acquisitions
Paul Klee
War Artist exhibitions
Picture of the Month

Select bibliography

The National Gallery archives

Kenneth Clark, *Another Part of the Wood,* London 1974

Kenneth Clark, *The Other Half: A Self Portrait,* London 1977

Martin Davies and Ian G. Rawlins, 'The War-Time Storage in Wales of Pictures from the National Gallery', *Transactions of the Honourable Society of Cymmrodorion,* 1946

Joyce Grenfell, *Joyce Grenfell Requests the Pleasure,* London 1976

Joyce Grenfell, *Darling Ma: Letters to Her Mother, 1932–44,* ed. James Roose-Evans, London 1989

Marian C. McKenna, *Myra Hess: A Portrait,* London 1976

National Gallery, *The National Gallery,* London 1938–1954

National Gallery, *National Gallery Concerts,* London 1944

F. Ian G. Rawlins, 'The National Gallery in War-Time', *Nature,* vol. 151, pp. 123–8, 30 January 1943

Meryle Secrest, *Kenneth Clark: A Biography,* London 1984

John Strachey, *Post D: Some Experiences of an Air Raid Warden,* London 1941

Photographic credits

First published in Great Britain in 2008 by
National Gallery Company Limited
St Vincent House, 30 Orange Street
London WC2H 7HH
www.nationalgallery.co.uk

ISBN: 978 1 85709 424 4
525526

British Library Cataloguing-in-Publication Data
A catalogue record is available from the British Library

Library of Congress Control No. 2008930462

Publisher: Louise Rice
Project Editor: Davida Saunders
Cover and text design: Smith & Gilmour, London
Picture Research: Suzanne Bosman
Production: Jane Hyne and Penny Le Tissier
Printed in Hong Kong by Printing Express

Front cover: Ideals of womanhood separated by four
centuries: Bonifazio di Pitati's *Madonna and Child with
Saints* being loaded into a railway company van bearing
a 1940s advertisement for Knight's Castile soap. The
painting was temporarily stored at the Prichard Jones
Hall of the University of North Wales in Bangor (shown
here), before heading to its permanent wartime home
in the caves of Manod quarry (back cover).

Page 1: Cover of a National Gallery album of
wartime photographs.

Page 2: Paintings waiting to be unloaded at Manod quarry.

Page 4: Masterpieces in hiding: Gallery staff at the quarry
move Veronese's *Allegory of Love, III ('Respect')* in one of
the store buildings. *The Family of Darius before Alexander* –
also by Veronese – can be glimpsed at the back of the
store, and Philippe de Champaigne's *Cardinal de Richelieu*
lies on a workbench in the foreground.

The author would like to thank Alan Crookham, Emily
Lane, Joan Lane and Keith Robinson for their help and
encouragement. Special thanks also go to Rachael Fenton,
Tom Patterson, Maria Conroy and Colin Harvey of the
National Gallery Photographic Department.